icons:
magnets of meaning

ic⬤ns:

magnets ⬤f meaning

Edited by Aar⬤n Betsky

with contributions by

Steven Flusty, Chee Pearlman, and David E. Nye

San Francisc⬤ Museum ⬤f M⬤dern Art

Chr⬤nicle B⬤⬤ks, San Francisc⬤

This catalogue is published on the occasion of the exhibition *Icons: Magnets of Meaning*, organized by Aaron Betsky at the San Francisco Museum of Modern Art and on view from April 18 to August 5, 1997.

BA

BankAmerica Foundation

Icons: Magnets of Meaning is made possible by major sponsorship from BankAmerica Foundation. Additional generous support has been provided by Mimi and Peter Haas and Mr. and Mrs. Charles Schwab.

Chronicle Books, 85 Second Street, San Francisco, CA 94105 www.chronbooks.com
Distributed in Canada by Raincoast Books, 8680 Cambie Street, Vancouver, B.C. V6P 6M9

10 9 8 7 6 5 4 3 2 1

Library of Congress Cataloging-in-Publication Data:

Icons: magnets of meaning / Aaron Betsky … [et al.].
 p. cm.
 Published on the occasion of the exhibition held April 18 to August 5, 1997
at the San Francisco Museum of Modern Art.
 ISBN 0-8118-1857-8
 1. Material culture—Exhibitions. 2. Icons—Exhibitions. 3. Art objects—Exhibitions.
4. Popular culture—Exhibitions. I. Betsky, Aaron. II. San Francisco Museum of Modern Art.
III. Title: Magnets of Meaning
GN406.I36 1997
707' .4'79461--dc21 96-46759
 CIP

Publication Manager: Kara Kirk
Designer: Aufuldish & Warinner
Editor: Fronia Simpson
Editorial Assistant: Alexandra Chappell

Printed and bound in Hong Kong

c ● n t e n t s

Director's Foreword

John R. Lane

Icons: Magnets of Meaning, the first large-scale exhibition conceived and realized for SFMOMA by Aaron Betsky, is emblematic of the broad vision, high ambition, fecund ideation, and discerning design judgment he has brought to the role of curator of architecture and design since he joined the Museum's staff in 1995. Positing that icons are objects of everyday use which, in their simple, dense abstraction, contain a universe of associations, Betsky has considered these ubiquitous, modernist artifacts of our designed environment from conceptual, formal, and emotional perspectives, endeavoring not only to analyze the design qualities wrought by their creators but also to reveal the layers of cultural meaning with which we, as consumers, have invested them. Our very warm thanks go to him for organizing this multifaceted project, including—in addition to the crucial and traditional curatorial responsibilities of selection and scholarship—designing the installation and commissioning a group of new icons.

On behalf of Aaron Betsky, I would like to extend sincere thanks to Mike Bell, Bob Bruegman, Peter Haberkorn, Jerry Hirshberg, Steven Holt, Michael McCoy, Gary McNatton, David Meckel, Chee Pearlman, David Resnicow, and Jaime Rua, as well as his SFMOMA colleagues Douglas R. Nickel, assistant curator of photography; Sandra S. Phillips, curator of photography; Robert R. Riley, curator of media arts; and John Weber, Leanne and George Roberts curator of education and public programs. Each of these individuals provided invaluable assistance in formulating ideas and editing content, for both the exhibition and the accompanying publication.

Thanks are also due to Matthew Maupin, Julie Min, Carla Murray, Sean O'Connor, Kimberly Rosenberg, and Henry Smith-Miller for help in designing the exhibition's complicated installation. Mark Fox of BlackDogma Inc. designed the icon emblems that enrich the installation—and this publication— and we thank him for his inspired efforts on our behalf.

Many staff members at SFMOMA assisted in the planning and presentation of *Icons.* In particular I would like to thank Lori Fogary, director of curatorial affairs; Snowden Becker, administrative assistant to the director; Carol Blair, museum technician; Lorna Campbell, assistant registrar; Neil Cockerline, associate conservator; Alina del Pino, museum technician; Kerry Dixon, on-call curatorial assistant; Sarah Emmer, architecture and design secretary; Jeremy Fong, assistant registrar; Sabisha Friedberg, research intern; Tina Garfinkel, head registrar; Barbara Levine, exhibitions manager; Jean MacDougall, former curatorial assistant; Kent Roberts, installation manager; Thom Sempere, graphic studies coordinator; Sandra Farish Sloan, public relations associate; Isabelle Sobin, research intern; Rico Solinas, museum technician; Marcelline Trujillo, exhibitions assistant; Greg Wilson, museum technician; and Samuel Yates, research intern.

Credit also is due to the numerous individuals who played important roles in the creation of this publication. For their insightful catalogue essays, I offer express thanks to David E. Nye, professor and chair at the Center for American Studies, Odense University, Denmark; Steven Flusty, doctoral candidate in the School of Urban Planning and Development at the University of Southern California; and Chee Pearlman, editor-in-chief of *ID Magazine,* who was ably assisted in her research by Nancy Herrmann. Museum staff members Catherine Mills, director of graphic design and publications, Kara Kirk, publications manager, and Alexandra Chappell, publications assistant; editor Fronia W. Simpson; and designer Bob Aufuldish all contributed their expertise to this project. We are also grateful for the interest and enthusiasm of our copublishers in this venture, Chronicle Books, in particular Christine Carswell, associate publisher; Annie Barrows, senior editor; and Emily Miller, associate editor.

Designers Liz Diller, Daniel Libeskind, Aldo Rossi, Stanley Saitowitz, Philippe Starck, and Tucker Viemeister were faced with the challenging task of

creating "instant" icons for the abstract notions of non-place, hope, fear, place (San Francisco), love, and hate. They responded to our request with characteristic creativity and enthusiasm, and for this we are deeply indebted.

We are especially grateful to the following individuals for facilitating the loan of objects featured in this exhibition and catalogue; Don Lindsay, Apple Computer, Inc.; Mark Wilhelm, Aprilia; Martha McKinley and Valerie Shurko, BMW; Vicky Hardy, Bosell; Deborah Walter, Braun; Kathleen Bertolani, senior communications manager, Easton Sports, Inc.; Ken Friedman; Marcena Peterson and Sally Pras, The Gap, Inc.; Brian Maynard, KitchenAid Home Appliances; Lynn Downey and Kay McDonough, Levi Strauss & Co.; Sheryl Burke, Limn, San Francisco; Angie Johnson and Laurie Witt, Nike, Inc.; Yvette Prado, Nissan Design International, Inc.; Al Brandenburg, OP Contract; Gillian Crampton-Smith, Royal College of Art, London; Beverly and Dave Dyc, Santa Cruz Surfing Museum; Kevin Thatcher, *Thrasher* magazine.

Finally, we acknowledge with great appreciation the generosity of the BankAmerica Foundation, whose major sponsorship has made *Icons: Magnets of Meaning* possible. We are equally appreciative of the munificence of Mimi and Peter Haas and Mr. and Mrs. Charles Schwab, who have provided important additional support for this enterprise.

Aaron Betsky

This exhibition brings
together twelve icons
of everyday life.

It argues that these designed artifacts are worth looking at, not because they are unique, but because they are so commonplace. It shows things we use everyday without even noticing them, suddenly framed in isolation, and asks what they mean. These icons propose that we consider as art the stuff that surrounds us all the time, wherever we are. Each of the twelve central icons sits within a group of objects that elaborates a basic form, function, message, or association. In addition, six designers have created their own icons expressing hope, fear, love, hate, place, and non-place. Works by artists who have played with, criticized, and elaborated icons course through the exhibition, making us aware of the tricks of which these strange objects and images are capable.

Why do we need these icons? In a world of continual change, we need something to hang onto. This exhibition collects objects that, through both use and design, have become anchors in a world in which continual movement and change have replaced static social, economic, and political statements. As all the fixed structures on which we once depended melt away, these objects remain as magnets of meaning onto which we can project our memories, our hopes, and our sense of self. These are beautiful objects that awaken our desires, but they are also, if we look at them carefully, in isolation, removed from use, strange and perhaps even frightening. Like rocks at the bottom of a stream, they have become honed down to smooth, abstract shapes that reflect all the ceaseless activity that courses around them, but they somehow remain solid and fixed. Our cities are disintegrating into sprawling landscapes of real estate developments. We communicate through the invisible networks of the electrosphere. Corporations, institutions, and whole countries are giving way to focused groups in loose confederation. We live in a period of tremendous freedom, but also of frightening disorientation. Some have called for the reintroduction of familiar forms, such as tradi-

tional Main Streets in the suburbs or cars that look like what we drove in our youth or our parents in theirs. Others have embraced dissolution with abandon, making objects that themselves are no more than momentary installations. Then there are icons. These are, on the simplest level, objects of everyday use. They are mass-produced and available (or so advertisers would have us believe) to almost everybody. They are successful because they work, because they are enmeshed in a system of selling, and because they somehow have caught our fancy, our eye, or our body. They have seduced us, collectively. What do these icons stand for? Not for one thing, but for many things at the same time. A pair of blue jeans might mean work, but it might also mean leisure time. It might mean a basic piece of clothing that you can embellish to make your own, a uniform that will make you fit in, or a high-design statement. The Luxor Hotel in Las Vegas might stand for gambling, for power, for modern architecture, for the desert, or for a hotel. A baseball bat reminds us of our youth but could also be a threatening weapon. These objects are so dense that they have become, perhaps paradoxically, abstract. Yet they are also commonplace. It is exactly because of their abstraction and universal appeal that they have the power to evoke a universe of meanings. They are the modern-day equivalent of the symbols, objects of devotion, or memory devices people once used to bring a sense of focus into their lives. Instead of being carefully guarded religious icons, these are icons of a consumer culture. Each of these twelve icons evokes a separate realm of associations. The blue jeans remind us how work and leisure, personal expression and uniformity, the body and the institutions into which we fit, are bound together. Lipstick allows us to make a face to meet the faces we meet, turning us into masks conforming to a mass image. The surfboard is a vehicle of freedom, but it is also an example of a class of object that became streamlined

through the application of new materials and technologies. The baseball bat is part of the game or part of the escape from the rules, depending on whether the terms of engagement are play or violence. The BMW is the ultimate driving machine that allows us to move at high speeds as the master of a great deal of machinery, and thus turns us into isolated cyborgs. The minicam allows us to film or be filmed and thus paradoxically imprisons us in a system of representation that gives us tremendous freedom. The KitchenAid mixer is an implement that brings the factory into the home and turns the home into an image of the factory. It is a lively and perhaps unnecessary part of a household filled with technological devices. The CBS logo embodies a vast corporate structure that we may be watching, or that might be watching us. It makes the global and the abstract specific. The @ symbol places us somewhere within a worldwide network and nowhere specifically at all. It makes us at home in the floating layers of information that surround us. The Luxor Hotel is the dark version of the modernist dream of all-glass buildings sheltering artificial environments. The intersection of the Sam Houston Tollway and the I-10 outside of Houston condenses those sprawling systems into monumental form. And the San Francisco Museum of Modern Art is a protector of art, a strong object in the city, and a building that appears to be halfway between something like a department store and a cathedral. **By looking at these icons in isolation, we start to wonder how their forms manage to embody and convey such a rich variety of readings.** We can see their formal properties, most of which have to do with streamlining, abstraction, the condensation of amorphous shapes, monumentality, and translucency. We speculate whether we can deliberately set out to create icons, as several designers here have attempted to do. We can see the relationship of these icons not only to utility but also to the capacity any

refined object has to make us wonder about, be critical of, or merely clearly see, the world around us, as some of the artists also shown here have already demonstrated in their work. The objects that surround each icon are meant to suggest, though by no means exhaust, some of the things each of the twelve central pieces can do. Some of them are iconic in their own right, others take the forms of the icon to extremes, but all of them contribute to our ability to make sense of some small part of our world through the medium of design. **The twelve icons are not the only ones operating in our society.** They were chosen because they seem particularly powerful to me and because I believe that they communicate that power to great effect. I am, of course, limited by my own perspective and accept the idiosyncrasies these choices may present. Certainly what appears as an icon to someone in my position, of my age, sex, income level, race, and nationality, might seem like an alien object to many others. Icons are, by their very nature, status objects. They are the centers of desire that help keep our highly stratified consumer society going by pretending that we need to work, not for "pie in the sky," but for the next gadget or piece of clothing we can charge. As such, these are not personal objects. They are icons that may represent an oppressive consumer culture to some, but I believe they will evoke multiple layers of association for others. They are icons many of us will recognize at first glance, and will wonder about after that. **The exhibition grew from the question whether design can still be relevant in our lives.** We no longer have an easy time believing that good design will make our lives better. Modern architects promised us utopia and gave us soulless cities. Product designers offered us efficient tools that in fact made our lives more complicated. Graphic designers only intensify the web of information that surrounds us. Good design, it turns out, does not always solve prob-

lems. Instead, it makes us aware of both problems and potentialities. It frames and forms the spaces we inhabit and the tools we use into coherent constructs that reflect our own humanity, which is our ability to make a world for and of ourselves. **Good design makes us wonder.** Most of the objects in the exhibition are the products of large corporations. This exhibition does not endorse these corporate entities but does enshrine the products they make. In some cases, we may question the ethical qualities of that production, or the uses to which these icons are put. That is the point. These icons cannot deny how they are made, how they are used, or what they might mean. By removing them from the racks, the showrooms, and the stores in which we usually see them, we ask them to justify themselves. They cannot, and so we must invest them with our own interpretations. The museum, by framing these objects with its own particular walls, security devices, backgrounds, and lights, forces us to look at them in isolation, rather than just accepting them. **Are they worth the attention?**

e s s

a y ✦ s

The Enigma of the Thigh Cho

Icons as Magnets of Meaning

Aaron Betsky

What is an icon in our culture?

Originally, it was a religious artifact whose subject and style were prescribed by tradition.

These conventional forms could bring abstract beings or ideas into a recognizable shape. Famous people or things can also become icons, as the Statue of Liberty or Abraham Lincoln have done.[1] Part of our twentieth-century loss of faith has been a loss of the kind of icons that are unapproachable, semidivine apparitions, and yet icons are all around us. The paradox this exhibition addresses is that some of the most normal, run-of-the-mill objects we use in the United States have become iconic. A surfboard, a mixer, or a building can become iconic. The simplest object, through both use and design, can take on tremendous importance in our world. It can become a carrier of meanings that allows us to see within its

simple shapes much larger structures. Icons of everyday use are haunted by a

long tradition by which mute objects are imbued with meaning, as well as by

over a century of modernist design that has sought to make the perfect form.

Icons are the haunted objects of modern design.[2]

We usually think of icons as either reli-
gious artifacts or representations that do not
merely stand for one thing but condense into
a visible form a much larger idea. Thus icons
are objects that present the unpresentable.[3]
They put into a physical form a force that we
cannot otherwise see, whether it is a divinity
or the mysterious working of a computer that
we control through a little icon on our
screen. The icon is a symbol in a material
form, an object of adoration, and a fetish,
and in all of these ways it creates something
we can see that condenses and makes physi-
cal the invisible or unnameable forces that
control our world. It is an object of art, use,
and mystery all at the same time.

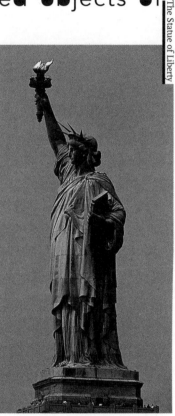

It is important to realize that icons are made, not born. They are reposi-

tories of meaning or carriers of import in which something remains. What

makes something into an icon varies from time to time and from place to

place. It used to be religion or myth, but these days it is as often as not

advertising or corporate public relations. That does not mean that icons

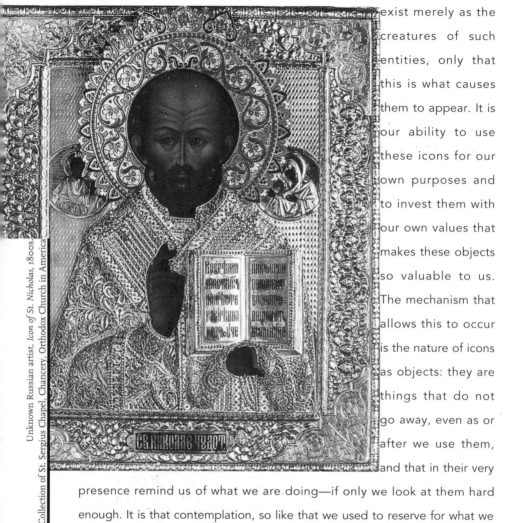

exist merely as the creatures of such entities, only that this is what causes them to appear. It is our ability to use these icons for our own purposes and to invest them with our own values that makes these objects so valuable to us. The mechanism that allows this to occur is the nature of icons as objects: they are things that do not go away, even as or after we use them, and that in their very presence remind us of what we are doing—if only we look at them hard enough. It is that contemplation, so like that we used to reserve for what we called art, that is the purpose of this exhibition. When was the last time we looked at a pair of blue jeans as an object, and realized what a pared-down uniform it is? Do we consider how much of its beauty is created by its association with western film heroes, and how much by its history as rebel clothing? Do we see in its fadings and patches the memories of what we were doing while we were wearing these pieces of cloth? If you frame this pair of blue

jeans, do not all of these associations well up?

An icon is also simply a status symbol. The economist Robert Reich has argued that we are becoming a society governed by "operators of symbolic logic": those who do not make or move things around, but those who condense bits of knowledge into obtainable units, whether as information, design, or structure.[4] What such operators need is icons. Most obviously, they need computer icons, since those little pictographs that form the heart of a "graphic user interface" (GUI) are exactly the nodes around which these networks of information circulate. But in a more general sense, they need what we sometimes call status symbols, tribal identification codes (ways of dressing), masks, core operating agreements, and other forms of coherence that may attach to a material thing but are separate from it: that is, icons. Thus icons are perhaps only truly operative for those who are so divorced from material work and a sense of continuity in time and space that they need an alternative material reference point that will allow them to place themselves in the here and now while reducing into an obtainable object a system over which they feel they should have some sense of control.[5]

Though this might seem to reduce icons to yuppie lust objects, it also points to their wider significance and applicability. Icons are usually nodes of information about the world, artificial containers of value, condensers of complicated technological structures and status symbols. The BMW 325i serves as a perfect example of such an icon. The "ultimate driving machine," it is a yuppie status symbol but also a refinement of automotive composition that exists at the intersection of the many different associations (speed, sex, technology, freedom, money) we have with automobiles. It stands for a car while also being a car.

It also means that we make our own icons, as much as they are made for us. In the past, we thought of those forces outside of ourselves as magical, or perhaps, at a later date, as political. These days, we are beginning to realize that it may be the very complexity and vastness of the reality we as human beings have created for ourselves that make it impossible to understand our world. Icons today are the end products of a complicated process of making, distributing, and selling things. As such, they function in a system of buying and selling, of telling and understanding, and of negotiating through a world dominated by technology that many of us find alienating. They represent that very world, and yet there is something familiar about them. A mixer might be either a yuppie symbol or a rational tool, but it is also a streamlined object that speaks about the future we once thought we were going to have.

These are, after all, artifacts: we have made them, and in that making lies a little piece of us. Icons, however, are artifacts that represent the artifactual nature of our world while they perform their specific tasks. They are not used up by use. As objects, they fit in our hands, and as spaces they contain us. Something remains even after we are finished using them. In ways that we cannot put our fingers on, they remind us of our bodies, our past, other human beings, and our future.

Instead of alluding to some unknowable force, offering themselves as a model to which we aspire, or presenting some notion of perfection outside our experience, our icons of everyday life give us memory and projection. They remind us of how they have been made and used, so that our whole past becomes present in a pair of worn blue jeans or a baseball bat, and at the same time they promise us future experiences—the liberation of driving a finely formed car, for instance, or the gamble between riches and poverty played out in a pyramid that mimics a tomb but is clad in the glass and steel we associate with the rational world of office buildings.[6]

Icons, finally, are condensations of who we are: they are the honed-down, perfected results of complicated manufacturing, distribution, and advertising processes on a vast and unknowable scale;[7] they are the result of millions of uses and modifications; they are just the right thing for the right activity that fits in the hand just so; they are the whole artificial universe we have created for ourselves and that is now so vast and complex that we can no longer comprehend it, made into a simple, dense object. The unpresentable that these icons present is our ability to make a world for ourselves, remaking ourselves into something called human beings who depend on and delight in artifice.[8]

BMW Design Sketch, 1996. Courtesy of BMW of North America

This process of reflective redefinition makes good icons very odd, queer, or weird. What makes something an icon now is not just its usefulness but its ability to remain after use, and what remains must resist our comprehension, further use, or interpretation. Icons of everyday use are those objects that resist classification, value engineering, and any other reductivist removal of meaning from them, even though they have been made possible exactly by processes of mass production and the relentless paring down of our economic system. A BMW coupe has been given its form after tens of thousands of hours of trying to fit as much safety, power, and sex appeal as is possible in a form that is cheap to produce, and its image has then been further honed by an elaborate advertising campaign. The result is not just a machine or an image, but both as one. Engineers and designers and advertising specialists made this object. They made it to appeal to as many of us as possible in as seductive a way as they could dream up. The object thereby has

taken on a sense of beauty that is specific to both its form and how we perceive it, one that conveys the fullness of all the technology of production that went into it.

It is that system of production (which includes marketing and advertising) that frames these icons. Take an icon out of context, and it will appear strange. It is the fact that we can take icons out of the loop that gives them their power. By appropriating, abusing, deforming, and reforming them, we make them our own. And yet they remain. It is exactly their enigmatic presence, which cannot be explained, that reminds us of the something that we have made, made ourselves into, or can remake. The iconic object sits there, a rebuke to everything except the fact of its making. It is a reminder, not of our mortality, what we once called a memento mori,[9] but rather of our ability to make.

Though we cannot explain them fully,[10] we can start to define what it is that makes an icon of things like a mixer, a surfboard, or a freeway intersection. The first principle of an icon is what I call the "wow syndrome," so-called after the moments when all you can say is those three letters.[11] It means that an object is "cool," but also "hot" with memories and associations that cannot be contained by a single phrase or image. Thus, the object has to be utterly familiar or mundane, and then surprise you when you see it in a new light. A sense of wonder wells up out of the weirdness of the object. Stuck in traffic at a freeway intersection, seeing the loops arcing overhead, serves to remind us of the freedom of movement—and the cruel frustration of its impossibility—implied by the highway. Such a sensation then offers us the possibility of remaining in awe or of using that realization as a critical tool to question the very structures of urban growth and engineering that have created such an object.[12]

Also characteristic of icons is their ability to create as much noise as communication. Most theories of communication are based on the premise that things acquire meaning in a relationship between the object doing the signifying (the sign) and the receiver. The process is mediated by the medium through which this exchange is taking place, whether that is the manner in which the thing appears, the interpretive template the receiver has at his or her disposal, or the medium out of which the signifier is made. Whatever has no direct context is captured through a symbol. The symbol brings the invisible into the world of the comprehensible and thus makes it into a thing.

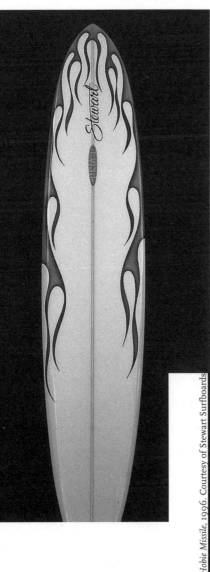

Hobie Missile, 1996. Courtesy of Stewart Surfboards

For the last few decades, philosophers have been pointing out that this loop is what defines us as human beings but also that it is what restricts us in a performative definition of what that means: we exist as human beings only as communicators whose reality is thus subject to a linguistic (i.e., sign-based) system that eventually becomes translated into laws and customs over which we have little control. The answer to this dilemma is to obfuscate, overload the system, or take apart the bits of communication to create the kind of noise that projects our humanity while not allowing it to be captured within a system of reception and interpretation. This is certainly a task graphic designers have set themselves as they create layouts that make the full complexity of our world present on the

page instead of pretending that it can be edited into simple blocks of text set in white space.[13]

Instead of speaking clearly, icons present enigmas protecting sense against interpretation. They often start as symbols, but then remain after we have made use of them to designate something that is otherwise unpresentable. Just as an allegory creates a layer of language that neither explains nor denotes an object, but puts it into a richer, allusive form that connects several real and imagined worlds, so the icon represents a thing, a use, and qualities that reach beyond that one-to-one relationship in a manner that we can elaborate endlessly. A lipstick is both an object of beauty and a palimpsest of it; it is a tool and a node in an allegorical description of how we present ourselves, as Alexander Pope knew almost three centuries ago, when he wrote *The Rape of the Lock* and presented the implements by which we put on our masks as animate beings that connect us to a mythological world of magic and attraction.

The reality, but even more the seeming mode of presentation, of the object is crucial to icons: it is all about how they appear.[14] This is the third quality of icons. There is nothing necessarily intrinsic about an icon. How it looks and, to a lesser degree, how it feels are what matter. The icon represents the unpresentable, but it is not it. The icon must hit you over the head and must be so thick with associations in the way it appears as to awaken all attendant associations. This is certainly true of the baseball bat, but also of such an object as the minicam, which looks like a slightly menacing piece of technology that spies on us or allows us to become semirobotic observers. There is no icon without appearance, and an icon is the most coherent, abstracted, full, and perfected form of appearance. There are many products that are mass-produced and readily available, but only relatively rarely does their design reach a point where they become iconic. The pickup truck, for

instance, despite the fact that it is used by millions and comes in thousands of variations, does not have an iconic appearance in the manner certain mass-produced sports cars (the Miata) or, only recently, passenger minivans (the Dodge Caravan) have attained. Icons are not the most popular or pervasive objects: they are the most beautiful.

This also means that icons are subjective and slippery in their definition. What appears iconic to me might seem merely mundane to you. **Certainly our perception of what is iconic is as much formed by the frame (society, our culture, the methods of presentation) as it is by the core object itself.** Icons change appearance depending on how you look at them, from what angle, in what context, or what you bring to your looking. The icons in this exhibition were chosen from the perspective of a white male living in California. What is iconic to me might be a quaint artifact or useless object to another. For icons to work, they must become the condensers of what the art historian Erwin Panofsky called "the more-than-practical world of customs and cultural traditions peculiar to a certain civilization."[15] This does not mean that icons are the sole representative of the mood of the times or the logical sum-mation of a certain culture, but rather that, over time, they become so molded by that culture that they become ways by which, if we look at them carefully enough, we can understand that culture. Icons are the repositories of meaning at a certain time and place and for a certain audience. They are made not by designers but by a process of condensation, though these days designers try to speed up that process by assimilating everything from art history to market research to create nearly instant icons. Thus one car designer was asked to design—and succeeded, if both the quality of the car as an object and its sales are any indication—an automobile with "instant heritage."[16]

In addition to such general characteristics, icons in our culture tend to have certain formal properties as well. The simplest hallmark of icons these days seems to be their fluidity. One could argue that icons are often bio-, zoo-, or anthropomorphic, and this connects them directly to our bodies. This is certainly one of the reasons why icons become successful, and this aspect of design has been described by some critics through what is called "human factors design" (and its predecessor, ergonomics) or through the notion of "emotive design."[17] It is true that icons hold up reformed and abstracted mirrors to ourselves, extend us out into the world, and reduce the myriad shapes of the world into forms that we can follow with our eyes and our hands. Thus the minicam is a fully ergonomic object that is as much shaped by the contours of our hands and our eye as it is by the technology inside it, yet it also looks like an extension of the eye, while at the same time recalling older still cameras, all packed into one fluid form.

One can also say that this fluidity is a result of what philosophers Gilles Deleuze and Félix Guattari have called "retroactive smoothing": the process by which an ever more complex system builds up so many layers and differentiations that they eventually all blend into a densely abstract construct.[18] In another sense, icons give shape to those fast flows of capital, the continual movement that is so central to our lives, and the speed that we associate with escape, with progress, and with freedom. The freeway is the frozen music of suburban sprawl. Icons are part of a world of fast cars and fast communication. They are streamlined to survive. Icons are the residual forms of the sprawling configurations of our cities and the electrosphere and take on the outline of the turning radius of a car or the waterlike flows of information.

It is also true, however, that icons are fluid because they cannot articulate their parts. As soon as they do that, each piece becomes an identifiable ele-

Pierre di Sciullo, "across illegibility," Emigre #18: Type Site, 1991. Collection of the San Francisco Museum of Modern Art. Gift of the artists, 92.22

ment of a conglomerate composition, rather than disappearing into a undefinable whole. This is certainly what the architect Frank Gehry, the product designer Philippe Starck, and the makers of cars seem to have discovered. It is also a quality that marks the work of graphic designers such as those published in the magazine *Emigre*, who blend text and context into densely layered rivers of type. When pieces of the icon do stand out, as in the case of the rivets on a pair of blue jeans, they do so as enigmatic emblems of an obscure former use or perhaps a promise of future attachment, rather than as functional items.

Icons are also smooth because they are mass-produced objects. That means they have to appeal to a wide variety of tastes and thus must be, to a certain extent, abstract.[19] When car designers talk about their designs, they speak in terms of target audiences. These, however, are multiples of tens of thousands of individuals whom they hope will respond, not to one specific shape, but to the suggestion of a line that is either more "masculine" or "feminine" or makes something "look like a pet."[20] Mass production also assumes an

optimization of material, and thus forms become compacted and have as few parts as possible. A sphere is the most efficient form that can be made, providing the largest volume with the least surface area and distributing forces equally around its face. Thus many objects tend toward this model of efficiency while becoming deformed by how our body uses them: the car wants to be a teardrop, but it has too many parts; the baseball bat is something we have to grip. Computer mice and minicams are equally streamlined.

ARCHETYPAL MEDIA IMAGE
WESTERN

THE WESTERN OR COWBOY PROTOTYPE IS IDEN-
TIFIED BY ARTICLES OF CLOTHING: COWBOY OR
WESTERN BOOTS, JEANS, FLANNEL OR WESTERN
STYLE SHIRT AND IN SOME INSTANCES HATS.
WHEN THE SCARCE APPEARS IN AN ANALOGUE
THE SETTING ARE USUALLY BARNS, CORRALS
OR FENCE POSTS. THE COWBOY REPRESENTS
THE FRONTIER AND A MALE ONLY SOCIETY.
THE MASCULINE QUALITIES OF THE WESTERN
ARCHETYPE ARE VIGOROUSLY EXPLOITED BY
ADVERTISING. MODERN COWBOYS ARE USED BY
THE MEDIA TO PLAY UP MASCULINITY AND SEX-
UALITY IN WAYS THAT ARE SUBCONSCIOUSLY
UNDERSTOOD BY THE GAY POPULACE.

Hal Fischer, *Archetypal Media Image: Western*, 1977. Collection of the San Francisco Museum of Modern Art. Gift of G. Austin Conkey, 84.79

Icons have to be able to move through that world of fast flows, and thus many are aerodynamically designed.[21] If they are mass-produced consumer objects, whether jeans or cars, they must be easy to pack to minimize shipping costs, and new scientific analysis is teaching us that square shapes are not optimal for distributing loads in tight configurations. Similarly, the forces that act on buildings, such as wind and gravity, are not linear. Thus efficient buildings become deformed by the need to resist those forces. From graphic design, we know that we read in a fluid fashion, not in blocks and bites, so layouts have to follow our scanning habits.

Fashion also plays a role: Raymond Loewy promised us that streamlined shapes would make our work easier, and even if they don't, they have an aura of scientific inevitability that enhances their iconic value.[22] Our culture has had a long romance with our ability to transform ourselves, and that belief in self-mutability was only reinforced by the invention of plastics and morphing.[23]

Finally, icons are fluid because we can make them that way. Computer modeling and analysis allow us to create virtually any shape we want in any quantity. We can then analyze its makeup and the forces that act on it, throw it out for test-marketing, form and reform it, and finally slide it into as many pockets as possible as the very realization of the new, the modern, that which we did not have yesterday but must have by tomorrow.

Many icons today also have one of two additional qualities: a sense of monumentality, or a translucency that is both sensuous and light. This is certainly the case in

most memorable recent architecture, a fact that several recent exhibitions have explored.[24] Buildings such as the Central Switching Station at Basel, designed by the Swiss architects Herzog & de Meuron, have the quality of being both very dense and very light at the same time. In a perhaps more banal but also more powerfully evident way, the Luxor Hotel in Las Vegas can appear monolithic at noon, like an eternal golden prism at twilight, and then as a tilted and tiled, transparent skin when the lights come on inside of it at night.

Monumentality has always been central to architecture, but we have usually associated it with either memorials or the fixing of order (whether political or religious) into a grand edifice.[25] These days, architects and many designers in other fields aspire to the creation of monumental forms whose density seems indestructible. It makes the buildings or layouts they design as somehow important and somehow strange.[26] These objects drink in light as well as meaning, sitting as enigmatic presences made of materials we cannot easily define. As such, they escape from the tyranny of type by which we relegate buildings to the realm where they must look like what they do or who uses them.[27] Instead, they reach beyond or deep into something we cannot classify and perhaps not even inhabit. Graphic design is filled with moments of

dense indecipherability that throw the task of constructing meaning back at the reader, while promising an untold depth of significance within its own layers of typography.[28]

Translucency is the icon's answer to the transparency of modernism.
Rather than reducing the world into rational bits that we can apprehend and thus use instantaneously, translucent icons such as the H_2O+ lipstick or a pair of translucent snow boots give a hint of their inner nature, but blur it. "Blur space" is in fact one of the experimental alternatives to the well-organized desktop we associate with the computer interface. It is a way of presenting documents in use in sharp focus, while other elements on the screen fade into the background, available but not distracting. The promise of what you can use and the memory of what you have used is always present. Translucent objects seduce, frighten, and draw you into them. They tantalize rather than tell and haunt our world as the scrims and screens that always seem to keep much of what we want out of our reach.[29] In a way, translucency is an emblem of a world of fear. It is about a fleeting shield between us and a world filled with both things we desire and things that harm us. It is the latex shield of the condom, the gloves the dentist wears, the shrink-wrapping around our food, the film that turns the transparent eye of the camera watching us into a mirror merely giving us back to ourselves in a deformed manner.

Because of these qualities of monumentality and translucency, icons can become frightening and seductive, and true icons are always both. They are filled with a sense of ourselves, of something we recognize and want to make our own again, and yet are profoundly other, enigmatic, and ultimately closed, drawing the sheath of artifice over the abstracted forms of recognition. They are markers of our alienation and question marks in a world of communication. If we once dreamed of a utopia of steel and glass, we now

Lip Style: Tahiti, 1996. Courtesy of H_2O+

recognize a more troubling perfection as the result of our progress through ever more sophisticated machinery.[30]

Perfection is the inherent hallmark of any icon. This is the case whether you think of geometry, form, or material. An icon is perfect not only because of the "wow syndrome" but also because the computer has optimized its form or because that form has been honed over thousands of uses, so that the icon is indeed the best possible tool for the job. As such, the icon is a modernist object. It stands at the end of a long line of rational pursuit of Platonic forms made of a material that is used to its fullest. It is, of course, a deformed version of the geometric shapes of which our culture once dreamed. Instead of globes and cubes, icons present themselves in teardrops, blobs, and shimmering planes. The ideology of modernism, the needs of our economic system, and the honing-down process of use, which acts like water on rocks, all come together to create perfection.[31]

Mario Perniola has argued that the renewed realization of perfection is central to our society. We can now make exact copies of things, endlessly, without any degeneration of successive models or deviation from the original. Often there is no such Adamic object, but only the intersection of zeros and ones on the designer's computer or the marketer's analysis. The icon is not an ideal, nor is it a second-rate simulacrum with which we must do: it is realized perfection.[32]

Icons are also standardized. Each of us, theoretically, can have one of those perfect copies. This means that the forms of an icon are recognizable because we perceive them as much in distraction as where we focus on them. Unlike a painting, **an icon inserts its perfection in our everyday life in such a way that we often do not even notice its arrival.**

James Dean, from the "Legends in Khakis" campaign, 1993. Courtesy of The Gap, Inc.

James Dean wore khakis.

GAP
KHAKIS

It is only when some circumstance—such as this exhibition—removes a mass-produced object from its context and highlights it that we become aware of its iconic quality. Icons we use often become our own through memories of specific things we experienced in them or with them, and we try to fix that memory by patching our own blue jeans, taking a snapshot, or sometimes enshrining an object on our mantelpiece long after it has outlived its useful purpose.[33]

The standardized aspect of the icon also creates what stands in for a sense of community. We recognize those who share interests and tastes with us across the globe through the icons they wear and use, whether it is the "good taste" implements of the kitchen or emblems of a certain status. Instead of emphasizing either their or our individuality, standardized icons bring home to us the common features that make up much of our lives and our bodies. In a world in which the differences between animate and inanimate objects, between energy and matter, and between consciousness and our physical being have come into serious question, the notion that these perfected objects might stand in for an irreducible kernel of the appearance of form can give a great deal of comfort.[34]

There is, of course, a sinister side to this standardization. We become the subject of assembly lines, advertising campaigns, a collective inculcation of values, and all the other processes that strip a notion of individual humanity away from our unique appearance in the world. A lipstick is a beautifully simple, round shape, but it also turns us into an image of something we have seen in a magazine. These systems threaten to replace our innermost private desires and fears with sound bites and clichés. If, as philosophers such as Donna Haraway and Luce Irigaray have argued,[35] we need to get away from the "border wars" that define such humanity, what then replaces the form of our body? Perhaps the fluid form of the icon, which is not our own and yet is our own, an abstracted version of self and others, a common form that yet contains the

internalizations and projections that make us each who we are, is the place where we can (re)construct such a notion of humanity.

It is then a sense of density that is the final and perhaps most traditional trait of the icon. An icon must, after all, represent without standing for one thing only. Like a religious icon, it must miniaturize a universe of meanings into a form that has a direct, but not a one-to-one, relationship both to our world and to our bodies, so that it becomes the in-between or relational reality of our lives. This means that the icon must become enigmatic.[36] An enigma, like a sphinx or an oracle, is a possessor of deep meaning that ultimately always says, "Know yourself." It protects that knowledge by building up layers of ritual in its use and protecting itself in forms that we cannot apprehend. The religious icon remains hidden, and from its protection emanates meaning. It can also be an object that is lost in everyday life, until its ability to connect us to larger forces stands revealed, as in the Arthurian sword. It is a mandala whose perfection brings out all the potential beauty of the world and our place in that world, but does so in an abstracted manner.[37]

We often forget that our icons of everyday life possess such power. It is by the way we treat them that their enigmatic quality comes out. The cars we truly value are objects of worship and protection. Favorite implements are talismans. Certain freeway intersections sort out the labyrinths of our interconnected lives into monumental mandalas of concrete and steel. The @ symbol is our place in placelessness. These are the mystical attributes of the icon, the things that allow them to replace symbols or signs. They are silent. They sit in our lives as anchors of meaning that sort things out for us without telling us where to go or what to do. They throw us back on ourselves.

The silence of icons, their survival beyond the closed circle of signification, is central to their functioning. It is what allows them to become magnets of meaning and nodes in the urban sprawl that is fast becoming the dominant landscape in which we live. It turns them into real pieces of utopias of resistive mementos of our lives. They are our nodes of connection to a larger world in which we have a place.

The philosopher Henri Lefebvre uses the notion of "representational art" to stand against the prisons of meaning that surround us on all sides.[38] He argues that we live through "representations" that organize the artificial world we have built up around ourselves. Representations are those images that we use to understand our world and make sense of it. They work according to a logic of linguistic systems in which we all have to take part and that in turn make us into nothing but senders or receivers of information. Representations cohere according to a system of values over which we often have no control. We are the subjects as well as the users of representations.

A representational art, on the other hand, is one that would exist, says Lefebvre, in an invisible manner. It is a resistive form of art that can be found in catacombs, in illegal underground meeting places, in art that no one understands, in the strange utterances of presumed schizophrenics, or in the poetics that evoke the earth, a smell, or a body without ever naming it. What is most important is that representational art is highly personal. It is what comes from a person, not so that we can understand it, but so as to represent that self in the world. A representational art would exist at the intersection between what appears and the inexpressible self.[39]

This is the hypnotic quality of icons: they are such a normal part of everyday life that they disappear, and in that very disappearance allow us to define ourselves.[40] This is, without doubt, an extremely romantic notion. One can just as well argue that icons are nothing but auratic objects of commodification: things that gain their value only from the structures of advertising that sell them and that replace an authentic sense of self with one borrowed from capitalist structures. Buying a car or wearing lipstick just means that you disappear into the masks of a mass-produced culture. This certainly is the interpretation of many analysts of "commodity culture."[41]

Yet something remains, reflecting off the surface of a car, rising with the color of the tube of lipstick, or hovering just beyond the @ symbol, something that defies such easy denigrations. It is something that is simply beautiful. Sometimes it even holds us in awe, lending a sense of sublimity to our lives. It is buried deep inside the objects and spaces of life. We can no longer find it in nature, which is now the subject of preservation, snapshots, and "extreme sports," that quest for thrills by using bicycles or climbing gear to go into dangerous terrain, nor even in the grand structures of the "second nature" (our man-made world of artifacts) we have made for ourselves, which is only a wasteful and ultimately useless attempt to forge an imitation reality. Rather, it resides in things we use, places we inhabit, and forms we appropriate.

Perhaps designers can create icons now, just as we can realize the iconic value of certain objects by putting them on display. What is essential is that icons have a quality of otherness that amazes and frightens us. This is something we often get by assimilating artifacts from other cultures, whether they are different in a national, racial, sexual, or even corporate sense. By mis-

using an object, layering it with our own intentions, and reforming it in our lives, it can become a commentary on how we create sense within our world.

The solid copper *thigh cho* is a strange object that illustrates some of the points about what constitutes an icon. It has a function—it is an incense burner—which gives it some religious overtones, thus already putting us in mind of something mysterious. As its part-English, part-Japanese name indicates, the *thigh cho* is also a version of a part of the human body, though it by no means represents my or anyone else's thighs: it merely evokes or intimates them. As an object, it is a composition of fluid forms whose copper burnish drinks in reflections while responding to the touch with the smoothness of forms that seem to fold back on themselves. Every time you follow a line with your eye or your hand, trying to find its geometry, its function, or its purpose, it slips away.

The *thigh cho* is heavy and odd. Set it on the table, and it organizes space around it by questioning the scale and even the function of that on which it sits. It reminds us of our body but transforms that memory into something polished and machined. It promises something in its abstraction, but we do not know what. It sits as an enigma, a dense and almost useless object amid the flow of papers, implements, and machines that populate my desk. The *thigh cho*, a gift to me by its Japanese designer, Atushi Kitagawara, is a beautiful object. It gains its beauty from its associations, its function, its forms, its abstraction, and its strangeness. It is an icon, but I do not know of what. Instead, it reminds me of what I do not know, but can touch, feel, look at, possess, use—and still it will remain.

Knowing by appropriation, making by making one's own, and defining oneself as part of a world of objects are the activities grounded by icons. To engage in such activities, we have to give up the notion that only the unique and crafted object has meaning. The *thigh cho* is a multiple, and its form speaks of machining, not the hand of the craftsman. For over a century, modernist

designers have tried to save the notion of craft as a revelation of the true nature of materials. Only by stripping things down to their basic functions, revealing their structure, and then creating articulated compositions, they believed, could we create forms that are true, honest, and beautiful. Such objects always became isolated fragments in an increasingly homogenized environment. They became the very emblems of the avant-garde.[42] Now it is time to realize the possibilities of revelation within mass culture itself.

The utopia we can look forward to is one of batch production, infinite controls, and webs of communication. If the technology of forming and design keep developing in the manner in which they are tending today, it will soon be possible to create highly specific objects with complicated compound shapes in very limited runs. It will also be possible to completely control the look, feel, and outlines of our environment at the touch of a button. Finally, we will be free to browse through infinite amounts of information and form them into whatever shape we like.

The question then becomes one of utopia itself: when all that is solid has melted into air, when anything is possible, and when all is abstract, what defines you, your world, and your actions?[43] In dystopic versions of such a future vision, the overwhelming possibilities enchain us into a McDonaldized and Microsoftian future in which all choices lead back to the lowest common denominator, so that we merely choose what is at hand. This is the favorite scenario of such cyberfiction writers as Neal Stephenson and William Gibson,[44] and the great fear of the editors of *Wired* magazine.

The alternative may be not to look for or fear such an ephemeral utopia, but to grab onto the actual objects that still inhabit our world: the streamlined, engineered results of our actions. In one way, they are nothing but condensed mirrors of our society,[45] the molds of our lives, and the leftovers of our progress into unknown and unknowable realms. They are the abstracted perfection of modernist design as real things, but they are also things we can own, remake, and fill with our own meanings. Once we have a kernel of such form, we can layer onto it our own personalities, extending ourselves into the world and into a social structure through common objects and spaces.

Fetishization may be the answer to commodification. The

thigh cho is not a critical object. Its presence will not change the world. It is probably a waste of precious natural resources. At first glance, it does not seem to express anything about my self, my race, or my gender. It may even be sexist. Yet it sits on my desk, drinking in the light, inviting strange desires, and promising perfection around each of its curves. In it, I can see possibilities of cars, clothes, and cameras. It exists between me and the world around me, condensing both of these terms into an enigmatic whole. It is my personal magnet of meaning, the very anchor of my hopes for design as that which might allow me to construct some sense of what it means to be human.

Notes

1. For a discussion of the transformation of iconic focus from religion to nature to manufactured artifacts, see David E. Nye, *American Technological Sublime*, 2d ed. (Cambridge, Mass.: MIT Press, 1996).

2. This exhibition is thus not about the most refined or optimal objects. We continue to refine designed artifacts to make them function better, but this does not always produce objects that haunt us. Nor does this exhibition present "quintessential" products that are the fulfillment of all our expectations of such objects. For an intelligent discussion of the drive toward this kind of perfection and its inevitable shortcomings, see Henry Petroski, *The Evolution of Useful Things* (New York: Alfred Knopf, 1992).

3. I here use the formulation of Jean-François Lyotard: "The postmodern would be that which, in the modern, puts forward the unpresentable in presentation itself; that which denies itself the solace of good forms, the consensus of taste which would make it possible to share collectively the nostalgia for the unattainable; that which searches for new presentations, not in order to enjoy them but in order to impart a stronger sense of the unpresentable." Jean-François Lyotard, *The Postmodern Condition: A Report on Knowledge*, trans. Brian Massumi, 2d ed. (Minneapolis: University of Minnesota Press, 1984), p. 81.

4. Robert Reich, *The Next American Frontier: A Provocative Program for Economic Renewal* (New York: Times Books, 1983).

5. This is certainly the belief of Julian Stallabrass, who writes: "Like the shopping centre which encloses it, the commodity presents itself as a monad. There is a link between the masking of social relations in the commodity form and its adoption of an apparently aesthetic meaning as an autonomous object. The commodity, like Athena, appears to be born fully formed and armed, without process and without manufacture. Its appearance is a miracle, the materialization of an ideal in which all marks of its making have been effaced. Like the reflective, uniform bodies of cars, contemporary commodities aspire to a seamless, resistant surface. The thing has its life because of labour but, since this labour is hidden, life seems to inhere in the object itself, as a mystic, aesthetic glow, which speaks directly to the beholder . . . so the commodity becomes like a work of art, auratic and mysterious . . . the material bodies of commodities are mere vehicles for a higher harmony which runs through the world, the object and the consumer, and will bring them to peaceful unity. Commodities aspire to a condition of transfiguration in which they become radiant, glowing or beaming like a 'face transformed by bliss' . . . Like symbols they seek to embody 'momentary totality', being self-contained, concentrated and steadfastly remaining themselves." Julian Stallabrass, *Gargantua: Manufactured Mass Culture* (London: Verso, 1996), pp. 157–158.

6. One might argue that icons are the carriers par excellence of what Richard Dawkins has termed the "meme." "All life evolved by the differential survival of replicating entities," he explains. In our world that replicator was the DNA molecule, but there can be others, and we have created a new "primordial soup" called human culture, with its own "unit of cultural transmission, or a unit of imitation." This is what Dawkins calls a meme. "Examples of memes are tunes, ideas, catch-phrases, clothes fashions, ways of making pots or of building arches. Just as genes propagate themselves in the gene pool by leaping from body to body via sperms or eggs, so memes prop-agate themselves in the meme pool by leaping from brain to brain via a process which, in the broad sense, can be called imitation." Richard Dawkins, *The Selfish Gene*, 2d ed. (Oxford: Oxford University Press, 1989), pp. 190–194.

7. One designer who has made this the focal point of his work is Ben Nicholson. His 1990 project *The Appliance House* started with a drawing of a small piece of a telephone, which Nicholson, in a series of conversations with the author, said he drew and redrew so that he could elicit the complex systems of design, manufacture, distribution, and use that shaped this small widget.

8. The icon thus takes on the function of a mandala, aedicula, or divining rod that connects us through an object of our own making to larger cosmic forces. For the most concise description of the role of such devices in architectural history, see Joseph Rykwert, *On Adam's House in Paradise: The Idea of the Primitive Hut in Architectural History* (New York: The Museum of Modern Art, 1972).

9. These were reminders of mortality that would take the form of skulls or bones placed in the margins of portraits or of the one piece of rotting fruit in a still life.

10. This is perhaps because they are the irreducible carriers of meaning. This is certainly how Charles Peirce defined what he called "conceptions": "This paper is based upon the theory already established, that the function of conceptions is to reduce the manifold of sensuous impressions to unity, and that the validity of a conception consists in the impossibility of reducing the contents of consciousness to unity without the introduction of it." Charles Sanders Peirce, "On a List of New Categories," *Proceedings of the American Academy of Arts and Sciences* 7 (May 1867): 287–298, 23–33.

11. Examples of such moments can be found in two scenes from popular movies: when James Dean, in the 1955 *East of Eden*, realizes that his brother's fiancée might love him instead, and when Marlon Brando, in the 1954 *On the Waterfront*, realizes that his brother has betrayed him, each can only mouth a voiceless "wow."

12. This "sense of wonder" was popularized in architecture by Louis Kahn, who believed it lay at the core of one's experience of architecture. For many of his students and followers, however, this became an excuse for inarticulate abstraction. Another sense of wonder was popularized by Charles Moore, who taught his students to delight in the sensuality of light, texture, and spatial progression. In both cases, the architects relied on existing typologies to develop this sense of wonder, and thus their work often remained hermetic.

13. The history of semiotics is obviously a rich and diverse annal of interpretations of signs and systems of reception. A central argument for the various methods of frustrating a "normal" cycle of interpretation is offered most coherently by Jacques Derrida, in *Dissemination*, trans. Barbara Johnson, 2d ed. (Chicago: University of Chicago Press, 1981). What is of special concern to me are the uses to which semiotic theory can be put. As N. Katherine Hayles has pointed out in her *Chaos Bound: Orderly Disorder in Contemporary Literature and Science* (Ithaca, N.Y.: Cornell University Press, 1990), the connections between literary theory and advanced scientific research have led philosophers to argue for the value of chaos, noise, and obfuscation—while scientists have continued to work to eliminate such interference.

14. I rely here on Hannah Arendt's speculations on the importance of appearance in her *Life of the Mind; One: Thinking* (New York: Harcourt Brace Jovanovich, 1971), in which she says: "could it not be that appearances are not there for the sake of the life process but, on the contrary, that the life process is there for the sake of appearances? Since we live in an appearing world, is it not much more plausible that the relevant and the meaningful in this world of ours should be located precisely on the surface?" (p. 27). She goes on to point out that "Art, therefore, which transforms sense-objects into thought-objects, tears them first of all out of their context in order to de-realize and thus prepare them for their new and different function" (p. 49). She also remarks that all such appearance takes on a quality of disguise or masking (p. 21).

15. Erwin Panofsky, *Studies in Iconology: Humanistic Themes in the Art of the Renaissance*, 2d ed. (New York: Harper Torchbooks, 1962), p. 11.
16. Jerry Hirshberg, conversation with the author, 7 August 1996.
17. Such theories of design were popularized by Michael and Catherine McCoy when they ran the Design Department at the Cranbrook School in Bloomfield Hills, Michigan. In an attempt to combine semiotics with ergonomics, they argued for design as a culturally and psychologically relative tool that externalized internal states of desire while adapting the exterior world to the emotive and physical structure of the body.
18. Central to Deleuze and Guattari's argument about this phenomenon is the emergence of what they call the "mechanosphere" and the notion that this ever increasing complexity folds into a renewed miasmic abstraction. They see this occurring in both cities and art but do not speculate specifically about designed artifacts. Gilles Deleuze and Félix Guattari, *A Thousand Plateaus: Capitalism and Schizophrenia*, trans. Brian Massumi, 2d ed. (Minneapolis: University of Minnesota Press, 1987), esp. pp. 499–500. Deleuze elaborated on this notion by quoting the Leibnizian notion of the "monad" in *The Fold: Leibniz and the Baroque*, trans. Tom Conley, 2d ed. (Minneapolis: University of Minnesota Press, 1993), going on to argue for the self-enveloping nature of art.
19. The process by which mass-produced products develop an aesthetic that is implied by their means of production and that tends toward a streamlined abstraction was first explored by Jeffrey L. Meikle in his *Twentieth-Century Limited: Industrial Design in America, 1925–1939* (Philadelphia: Temple University Press, 1979). He then specified his speculations through an exhaustive look at the results of the introduction of artificial materials into production processes in *American Plastic: A Cultural History* (New Brunswick, N.J.: Rutgers University Press, 1995).
20. This is the quality sought by David Smith, senior designer at Chrysler on the Dodge Neon project. He based his desire on his experience with a Honda Civic. Interview with the author, 12 January 1996.
21. This aerodynamic quality is the subject of a forthcoming book of essays edited by Michael Bell, entitled *Slow Space* (New York: Monacelli Press, 1997). In it, Bell will argue for the necessity of "slow buildings in fast space."
22. See Meikle, *Twentieth-Century Limited*, p. 165.
23. "Pragmatism's concept of a malleable universe open to human influence appealed to desires similar to those motivating plastic's development. To shape the stuff of existence at a fundamental chemical level, to imbue it with properties, textures, and colors unknown to earlier generations, to mold from it objects and environments unknown to prior civilizations—all these marked a degree of human control over nature that [William] James would have applauded at first, though eventually he might have feared its hubris. Whether used to imitate traditional materials or to create seamless artificial surfaces, plastic established unprecedented control over the material environment. Taken to extremes, such control implied the possibility of stifling humanity in a rigidly ordered artificial cocoon. There was something about plastic's chemical artificiality, as Barthes implied, that evoked the permanence of death. . . . On the other hand, plastic promised material freedom, a malleable environment." Meikle, *American Plastic*, p. 9.
24. *Light Construction*, organized by Terence Riley, ran at the Museum of Modern Art in New York from 21 September 1995 to 2 January 1996; Rodolfo Machado and Rodlophe el-Khoury's *Monolithic Architecture* was presented at the Heinz Architectural Center, The Carnegie Museum of Art, Pittsburgh, from 30 September 1995 through 11 February 1996.

25. See also Kurt W. Forster, "Monument/Memory and the Mortality of Architecture," *Oppositions* 25 (1982): 2–19.

26. This movement is especially strong in Switzerland, where architects such as Herzog & de Meuron built on the teachings of Aldo Rossi, who proposed architecture as a fusing of personal and societal memory into a physical form at the Eingenossische Technische Hochschule in Zurich during the 1970s, and on the engineering traditions of the country itself, to create heavily material and yet enigmatic buildings. Dutch designers such as the Office of Metropolitan Architecture, Mecanoo, and Ben van Berkel, on the other hand, have mined the very abstract, nonfigurative character of modern architecture with the same monumental and enigmatic results. In the design of objects, Philippe Starck has created playful forms whose weight derives from their evocative strangeness.

27. In architecture, the notion of "type" is central to the codification of design methodologies. A central tenet of the Ecole des Beaux-Arts in Paris during the nineteenth century, it was an attempt to reduce the differing appearance of buildings to general variations on basic geometries, facades, and planological organization. It also expresses a relationship between such inherent properties and certain programs with which these forms have become associated. In graphic design, type refers to the style of the letters themselves, which have become infinitely more malleable with the introduction of the personal computer. Here, too, type has come to be identified with the codification of certain inherent rules and the expression of content through appropriate type choices.

28. A good example of such a design approach can be found in the magazine *Emigre*, published in Sacramento, California. Most recently David Carson has popularized these notions in magazines and mass-market advertising, as well as in his book *The End of Print* (San Francisco: Chronicle Books, 1996).

29. Experiments with "blur space" were conducted at MIT's Visual Language Laboratory under Muriel Cooper in 1992 and 1993 and are only now beginning to make their way toward commercial application. There is an obvious connection between such an approach to interface design and notions of fuzzy logic and indeterminacy.

30. Icons have this power also because they have a sense of the *unheimlich*: that which is eerily familiar and yet disturbing. Anthony Vidler, in his *Architectural Uncanny: Essays in the Modern Unhomely* (Cambridge, Mass.: MIT Press, 1992), has traced this notion through the history of architecture and points out how an awareness of these qualities stands several modern architects such as Bernard Tscuni, Aldo Rossi, and Frank Gehry in good stead, as it allows them to evoke much deeper emotional responses from users than one would expect from otherwise abstract structures.

31. "For what is essential now appears no longer to be the actual, but rather the virtual; no longer the instant, but the memory; no longer the mingling of heterogeneous entities, but one-off precision; no longer the appearance, but the thing itself; no longer the ephemeral, but the available; no longer consumption, but conversation; no longer the fortuitous, but the perfect." Mario Perniola, *Enigmas: The Egyptian Moment in Society and Art*, trans. Christopher Woodall, 2d ed. (London: Verso, 1995), p. 61.

32. "If the straight line is the geometrical metaphor best able to describe progress towards a vanishing point, the dot is the clearly delimited element of precision that makes distinction, separation and discrimination possible. In mass-media society, everything can be traded for, and confused with, everything else; everything flows along in an uninterrupted stream of collective consciousness, in a torrent of images that succeed one another without pause. In information society, everything is fixed, anchors in a spatial order and assumed to be present and available. A world

whose basic tonality consists in a seamless subjective psychological temporality thus gives way to a world whose basic tonality consists in the parcellization and spatialization of psychological experience, owing to which states of adamantine calm can precede or follow states of delirium. Our spirit is no longer a stream, but an archive, a media resource center, a library. The principle on which mass-media society was founded was ephemeral consumption, an ever more dizzying 'use and discard' approach. The principle upon which the society whose advent is now announced is based is, on the contrary, the accumulation of data, information and images and their orderly management." Ibid., p. 66.

33. It is for this reason that many critics argue for the importance of waste—basing themselves on theories of potlatch popularized by such thinkers as Georges Bataille—and graffiti. For instance, this is the attitude of the cult-favorite philosopher Paul Virilio: "To look at what you wouldn't look at, to hear what you wouldn't listen to, to be attentive to the banal, to the ordinary, to the infra-ordinary. To deny the ideal hierarchy of the crucial and the incidental, because there is no incidental, only dominant cultures that exile us from ourselves and others, a loss of meaning which is for us not only a siesta of consciousness but also a decline in existence." Paul Virilio, *The Aesthetics of Disappearance*, trans. Philip Beitchman, 2d ed. (New York: Semiotext(e), 1991), p. 36.

34. Manuel De Landa, in his essay "Nonorganic Life" (in *Incorporations*, ed. Jonathan Crary and Sanford Kwinter [New York: Zone Books, 1992], pp. 129–167), recites many of these ambivalences, in the end arguing for the vitality of cultures at the point of "state change." He compares artists to metallurgists who push their material right to that undeterminable moment when it changes from liquid to solid form in order to perfect it.

35. Donna Haraway, *Simians, Cyborgs, and Women: The Reinvention of Nature* (New York: Routledge, 1991); Luce Irigaray, *An Ethics of Sexual Difference*, trans. Carolyn Burke and Gillian C. Gill (Ithaca, N.Y.: Cornell University Press, 1991).

36. "Unlike the secret, which is dissolved in the process of being communicated, the enigma is capable of simultaneous explanation on many different registers of meaning, all of which are equally valid, and it is thus able to open up an intermediate space that is not necessarily bound to be filled. . . . For can a society in which nobody any longer knows what is really happening, in which it seems impossible to calculate exactly the manufacturing cost of anything, and in which a state of organized uncertainty reigns in every walk of life, still be defined as a society of the secret? It is in reality a society of enigma. . . . The enigmatic character of art and philosophy is therefore founded not on their distance from the real world, but on the contrary, on the fact that the essence of reality is enigmatic. . . . Enigmatic words and tales are first and foremost words and tales that are rich in meaning, heavy with significance, fertile with valuable teaching. . . . To speak in enigmas is to say words that are important, worthy of the greatest attention and capable of penetration only after lengthy experience and profound meditation." Perniola, *Enigmas*, pp. 10–15.

37. A mandala is a device used in Indian art to denote the form of an all-encompassing divinity. It was most notably picked up by C. G. Jung in his *Mandala Symbolism*, trans. R. F. C. Hull (Princeton, N.J.: Princeton University Press, 1972).

38. Henri Lefebvre, *The Production of Space*, trans. Donald Nicholson-Smith, 2d ed. (Oxford: Blackwell Publishers, 1991), pp. 33ff.

39. Lefebvre goes on to argue (pp. 170ff.) that such an art would be based on the basically anthropomorphic qualities of "socialized spatiality" that we experience as space emerges as a social product through our exploration of our environment.

40. They may thus be perceived in what Walter Benjamin termed the "art of distraction": "Tactile

appropriation is accomplished not so much by attention as by habit. . . . This mode of appropriation, developed with reference to architecture, in certain circumstances acquires canonical value. . . . Distraction as provided by art presents a covert control of the extent to which new tasks have become soluble by apprehension." Walter Benjamin, "The Work of Art in the Age of Mechanical Reproduction," in *Illuminations* (1936), ed. Hannah Arendt, trans. Harry Zohn, 2d ed. (New York: Schocken Books, 1969), pp. 217–251, quotation from p. 240.

41. Stallabras's *Gargantua* remains a good example of such interpretations: "Identity is, then, constantly remade for us, and presented to us as a natural, exterior force. This process has been exacerbated lately, not by the fall of agreed aesthetic standards or because of some crisis of modernity, but rather because of an intensification of economic competition. . . . Producing the ephemeral is more an effective economic strategy than a cultural imperative, as [David] Harvey notes, for if there are limits to the accumulation and turnover of physical goods in saturated markets, then it makes sense for capitalists to turn to providing ephemeral services" (p. 9).

42. This was certainly the core of the Arts and Crafts movement, which presaged modernism. It may be interesting to revisit the distinction Reyner Banham made in *Theory and Design in the First Machine Age* (London: The Architectural Press, 1960), pp. 18–43, between a modernism based on an appropriation and exposition of technology versus an architecture that sought to impose perfected form on the world. Though many, including this author, have read this interpretation as revealing a story of the suppression of the "authentic" avant-garde by an elitist modernism, the persistence of form as something purposefully alien may turn out to offer more opportunities for resistive self-definition and social action than previously supposed.

43. This is the central question asked by Marshall Berman in *All That Is Solid Melts into Air: The Experience of Modernity* (New York: Simon & Schuster, 1982).

44. Gibson, in his trilogy *Neuromancer* (New York: Ace Books, 1984), *Count Zero* (New York: Arbor House, 1986), and *Mona Lisa Overdrive* (New York: Bantam Books, 1988), invented the genre of "cyberpunk," which has since been carried on in a more Pynchonesque mode by Neal Stephenson in *Snow Crash* (New York: Bantam Books, 1993) and *The Diamond Age* (New York: Bantam Books, 1995).

45. I here use Michel Foucault's notion of the mirror: "[I]t is a place without a place. In it, I see myself where I am not, in an unreal space that opens up potentially beyond its surface; there I am down there where I am not, a sort of shadow that makes my appearance visible to myself, allowing me to look at myself where I do not exist. . . . Hence the mirror functions as a heterotopia, since it makes the place that I occupy, whenever I look myself in the glass, both absolutely real—it is in fact linked to all the surrounding space—and absolutely unreal, for in order to be perceived it has of necessity to pass that virtual point that is situated down there." Michel Foucault, "Other Spaces: The Principles of Heterotopia," *Lotus* 48–49 (1986): 10–24, quotation from p. 12.

Icons in the Stream: On Local Revisions of Global Stuff

Steven Flusty

During the summer of 1996, one couldn't see Atlanta for the logos. Major

streets were festooned with jewel-toned banners shrieking names of Olympic

sponsors (**Delta**, **Xerox**, **UPS**) in type twice the size of that announcing the

Centennial Olympic Games.

Beneath the shadow of the **CNN** Center (and atop the graves of three downtown homeless shelters[1]), the icons were having a picnic in Centennial Olympic Park, wolfing down market shares and strutting before the electronic eyes of the world. The **AT&T** Global Olympic Village sat clothed in a hyper-chromatic echo of **Disney**'s It's a Small World, surmounted by the company's logotypic striped circle suggesting a globe in prisoner's garb. The looming aluminum **Swatch** pavilion sent sprouts throughout the park, giant Swatch wristwatches springing from the pavement and embedded in a dragon-topped concrete column like parodies of civic sculpture. Overhead, the world's largest blimp paced the sky, slathered with the **Krogers** supermarket logo.

The **Krogers** blimp, however, was more than advertising. The supermarket donated the airship, with promiscuous fanfare, for aerial policing of the festivities below. The blimp thus emblematized the phenomenal disciplining required to enforce correct reception of this international sporting event turned corporate carnival. Bus fleets converged on the park, carrying visitors to and from far-flung venues. Video cameras covered every square inch of highway, twice. Tens of thousands of pith-helmeted security, police, and national guard personnel ensured that visitors' deportment remained subscriptive to the event's prescribed[2] meanings, flows, and commercial appetites.

Despite the efforts of these quasi-public mechanisms to bolster Antonio Gramsci's equation of corporately controlled mass production and communications with industrially produced consciousness, Louis Althusser gained the upper hand as miscoordinations within and between Olympian institutions of control associated corporate sponsors with comically misreported scores, hopelessly impacted subways, absentee shuttle buses, and erratic, labyrinthine identity checks. And through these breaches in discipline stepped one of Michel de Certeau's tactics for meaning appropriation, a

explosion beneath the **NBC** Sound and Light Tower that instantly converted the corporate iconography of Centennial Park into a backdrop for ripped bodies and patrolling bomb squads.

These circumstantial subversions of mandated iconic readings mirror the horrors of fixing meaning in the face of dissonances between global flows and varied local conditions of daily life. In the chaos generated by the intersecting of what Janet Abu-Lughod has called "the upper circuit and local stickiness," no center can possess the capacity to control how its cultural forms are interpreted.[3] As individual forms and meanings of this cultural output are selectively adopted elsewhere, icons lose their original cultural context and so undergo slippage in meaning[4] as they are (re)interpreted for integration into the recipient's divergent cultural matrix.

With this decontextualization of the icon and its reinterpretation within new cultural matrices, de Certeau's assertion that meaning is made in the use of a thing goes global as transnational corporate production and distribution provide an iconic mulch from which local webs of interconnected actors assemble meaning as they negotiate the courses of everyday life.[5] This global multilectic of iconic interculturation is legible in the malleability of meanings attributed to the output of two of Centennial Park's heartiest partyers: **Coca-Cola** and **Nike**.

A cold, sugary, and heavily caffeinated tonic for the lethargy-inducing heat and humidity of the Southern summer, **Coke**'s status as Atlanta's native son was apparent in the omnipresence of the **Coca-Cola** bottle's components and "classic" hourglass figure. Gigantic bottles protruded above milling crowds, umbrellas emblazoned with the "dynamic ribbon" squatted atop armadas of snack tables shaped like giant red bottle caps, the **Coca-Cola** Olympic City offered $13 simulations of the athletes' experiences ("feel what it's like to live the Olympic Dream") in a pavilion stuffed with bottle-shaped

55

This space originally held an image of a gold commemorative Coke bottle. Permission to reproduce this image was denied by Coca-Cola.

kiosks, hung with bottle-emblazoned banners, even employing the bottle silhouette in place of the *i* in *City*. In gift shops, the bottle was permuted into a plethora of incarnations, including the limited-edition gold-plated glass contour bottle, "the most perfectly designed package in use . . . recognized worldwide as synonymous with the product **Coca-Cola**," stamped with the Olympic logo, and "sure to bring back the nostalgia associated with the traditional 6.5 oz. bottle."

Such bottle plaudits underscore the pragmatics of **Coke**'s global presence; without the bottle **Coke** would have remained confined to retail outlets equipped to combine syrup with carbonated water in correct proportion. The bottle, however, means more than portability. Officially, **Coke** is refreshment or, more cynically, a quick, cheap, and legal high. The bottle's contour may imply this pleasure (for some) by mimicking the female body,[6] particularly in the exaggerated, corsetlike curves of early prototype bottles clearly modeled after the torso of the turn-of-the-century Gibson Girl.

Despite sales in forty-five different countries by 1940 and an ingredient list drawn from four continents (including, until the 1930s, Peruvian coca), the fact that **Coke** was "drunk in every state and territory of the United

States" by 1895[7] and the quantity in which American soldiers and tourists were seen to consume it following World War I resulted in the **Coke** bottle's characterization as an inherently American cultural commodity.[8] World War II reinforced this reading, as **Coca-Cola** established bottling facilities everywhere United States forces set foot, ensuring a global network of bottling plants by war's end. With the postwar initiation of U.S. economic hegemony and dissemination of American cultural products worldwide, the **Coca-Cola** bottle became "the most widely recognized commercial product in the world."[9]

This recognizability was not necessarily advantageous. The bottle's presence in war-ravaged Europe came to represent the economilitary dominance of those culturally insensitive moneygrubbing American boors, a perception reinforced during the late 1940s by **Coke**'s efforts to promote itself in architectural icons of European civilization: birdseed laid out in Venice's Piazza San Marco to spell a giant **COCA-COLA** in pigeons; a phalanx of **Coke** delivery trucks in front of the Roman Colosseum.[10] The **Coke** bottle's recontextualization as an implement of U.S. imperialism was cemented in 1950 when, during anti-**Coke** rallies in France, the French Communists coined the cautionary term *Coca-Colanization*, while bottles of **Coke** were smashed in street demonstrations warning against the conversion of Europeans into *cocacoliques*.[11]

With **Coca-Cola** bottled in 160 countries and controlling 50 percent of the world soft-drink market by 1990, more ambivalent readings of the **Coke** bottle prevailed, particularly in the ever-expanding "Third" World. On the one hand, the labor practices of local elites-cum-bottling-franchise-licensees served to equate the **Coke** bottle with oppression, especially for those who put the beverage in the bottle: in Guatemala, numerous unionizing **Coca-Cola** bottling workers were executed by local bosses and government-supported death squads.[12] On the other hand, the **Coke** bottle contains the

semi-imaginary affluence of a globalized America: in rural Tanzania, where **Coke** is coveted both for warding off equatorial heat and as a symbol of a luxurious world beyond, **Coke** bottles are displayed around (or incorporated into the architecture of) village domiciles to indicate the consumer's ability to afford comparatively expensive nonlocal beverages.

Many of these villages harbor traditions of mahogany carving. Earlier animal motifs remain popular, although these are now produced primarily for export by village carving collectives. By contrast, carved **Coke** bottles complete with the "dynamic ribbon" logotype in high relief are prized pieces that have tended to remain within the community.

The insularity of these objects, however, has eroded as they come to symbolize, for collectors of African handicrafts, the peculiarities of the "primitive's" adaptation to the modern. Thus, like the **Coca-Cola** bottle itself, the mahogany **Coke** bottle becomes an icon while, like the limited-edition gold-plated contour bottle, this commodity fetishized in mahogany becomes a globally commodified fetish, turning up as fifty-dollar folk sculptures in the world cities of **Coke**'s home country.

Although which beverage would prevail in the contest for Olympian innards was never in question, competition for the surface of the Olympian body remained intense, with **Nike** and **Reebok** going head-to-head. **Reebok** was prominent on the field, clothing entire teams (especially those from debt-ridden neo-nations). **Nike**, however, emerged victorious. A blitz of billboards and murals augmented an amphitheater pavilion, over which towered a monolithic red **Nike** Swoosh logo. Over the pavilion's entrance crouched a postmodern consumerist equivalent of "Arbeit Macht Frei," JUST DO IT, spelled out in thin black sans-serif metal.

The hyperbole of this comparison is lessened when one considers the **Nike** Air shoe from the perspective of those assembling the shoes in the

readily replaceable factories of **Nike**'s Asian subcontractors. For the typical **Nike** assembler in Indonesia, a woman in her late teens or early twenties from some outlying agricultural area,[13] the **Nike** Air represents long hours, poor working conditions,[14] and approximately $2.26 per day, below the Indonesian government's definition of "minimum physical need" but enough to rent a shanty without electricity or running water on the outskirts of Jakarta.

Such "ruthlessness with which **Nike** pares its costs"[15] helped the company become the highest-grossing sportswear manufacturer globally, selling in eighty-two countries.[16] The **Nike** Air, however, is not marketed for profitability but for high performance, although some 50 to 80 percent of production never sees athletic use (a phenomenon known as "implied performance" at **Nike** headquarters' World Campus in Beaverton, Oregon).

Associating **Nike** Airs with athletic superstars has been central to equating the shoes with victory, most significantly with the multiyear, multimillion-dollar endorsement contracts linking Chicago Bulls guard Michael Jordan to the Air Jordan basketball shoe. In addition to being a basketball great, Jordan is an African-American "bootstrap" success, and **Nike** capitalized on this matrix of rags-to-riches and sport, "a circumscribed zone where blacks are allowed to excel,"[17] by employing Spike Lee and coach John Thompson for commercials while pushing the shoes "in the toughest parts of cities like

Unofficial, unlicensed solid mahogany Coke bottle replica, unnumbered

"Oakland, Washington, D.C., and Detroit."[18] As a result, **Nike** Airs became a hot property in the poorest urban areas.

Unfortunately, deindustrialization and economic evisceration[19] of United States urban cores served to render the $115.50 air-cushioned signifiers of accomplishment inaccessible to precisely the respect- and cash-starved black youth market most heavily targeted by **Nike**'s promotion. By 1990 numerous kids who could not afford the shoes got them by assaulting, and occasionally murdering, those who could.[20] The **Nike** Airs thus became an icon to kill for, echoing the urban myth that a pair of athletic shoes, tied together and thrown to hang from overhead phone lines, indicates the site of the wearer's street killing.

With Latino populations immigrating to African-American neighborhoods throughout the 1980s and 1990s, **Nike** Airs underwent further redefinition. This was particularly pronounced among young Latinas anxious to escape subordinate female roles, who were receptive to **Nike**'s "feminist" campaigns conflating athletics, and by association **Nike** wear, with female empowerment.[21] **Nike** Airs' resulting symbolic power finds expression in "The Storyteller with **Nike** Airs." Lucia, a *curandera*'s young apprentice

J U S T D O I T .

Centennial Olympic Park—adjacent pavillion by Nike, not an official sponsor

dressed in pink-and-lavender **Nike** Airs, journeys through a dying farmwork-
er's imagination, only to encounter *juveniles de sombra*, dissolute shadow kids,
hanging out on the psyche's street corners. The strongest shadow kid thrusts
a "sickening green ooze" of "desire-to-have" toward Lucia's feet, and, after an
exchange of threats, Lucia trades her **Nike**s for directions to the farmwork-
er's soul. "Lucia handed over her **Nike**s and the shadow leader, with this
added strength, sucked the other shadow girls in with a smack."[22]

Simultaneous with the **Nike** Air's recontextualization among propin-
quous ethnicities, the icon underwent export as a stowaway aboard hip-hop.
Originating in the South Bronx,[23] hip-hop culture expressed, in lyrics rapped
to sampled sounds and graffiti sprayed on appropriated wall surfaces, the
resistance of marginalized young blacks to a larger society that proffered the
options of malign neglect or criminalization.

This music culture rapidly spread throughout the United States and into
a black Atlantic circuit of exchange connecting the African diaspora in
America with its counterparts in the Caribbean, Europe, and Africa itself.[24]
Concurrently, rap trickled down to other marginalized minority youth (e.g.,
Dutch Indonesians, New Zealand Maoris) and to sympathetic or merely rebel-
lious children of more privileged social formations. Given the popularity of
Nike Airs among U.S. black youth coincidentally acting as hip-hop's progeni-
tors, the shoes became an international icon of hip-hop's resistance to mar-
ginalization and oppression: access to the latest **Nike**s available only through
American or British connections defined the most serious European home-
boys and fly girls.[25] This prevalence of **Nike**s on the feet of rappers worldwide
led the Senegal-born French rapper MC Solaar to criticize global emulation of
U.S. hip-hop idioms as "the cult of the sneaker."[26]

The international recontextualization of **Nike** Airs was represented in
Mathieu Kassovitz's 1995 film *Hate* (*La Haine*). Set to a rap score, *Hate* fol-

lows a day in the life of three kids, one Central African, one North African, and one Jewish, living in the "Bluebell" *cité* (public housing project) on the outskirts of Paris. Throughout the film, the kids respond to repeated insults by the Parisian elites and gendarmes with braggadocio and often misdirected aggression. The most overtly angry of the three is signified not just by his actions but by his **Nike** Airs and, in numerous scenes, full **Nike** workout suits.

While the *cité* pitched **Nike**s as icons of violent alienation, **Nike** called up Central Africa as symbolic of the product's global reach and, by proxy, that of the wearer. An advertisement targeted at wannabe adventurers depicted **Nike** hiking shoes tromping across Kenyan veldt, closing with shots of local Samburu tribesmen. In close-up, one Samburu says something in the native Maa tongue, while **Nike**'s "Just Do It" slogan appears across the screen as if in translation. In fact, the tribesman said, "I don't want these. Give me big shoes." When the advertisement aired in the United States, Maa speakers commented on the discrepancy, including one who reported it to *Forbes* magazine, which in turn disseminated the story to numerous newspapers and, from there, onto the Internet. Responding to the accusation that the company misquoted the

Samburu, a **Nike** spokesperson said, "We thought nobody in America would know what he said."

What **Nike** failed to recognize is that the same currents of transportation and communication that export icons into new contexts also scatter the denizens and lifeways of those new contexts equally broadly. The resultant world culture of densely overlaid and interpenetrating cultural contexts undermines consistency of meaning both globally and locally, rendering the icon polysemic and, quite often, self-contradictory. While such omnipresent, multiple recontextualizations need not entail the death of the icon as conventionalized representation of specific underlying objects, it does confer on such determined iconic meanings a radically shrinking shelf life.

The Official Air Max Nike, 1987

Notes

I would like to thank Kedron Parker, Paul 2000, and Emily Stukey for Olympic access; Enaj Lee and Polly Svenson for observations on soft drinks in Africa; Cheryl Endo for Nike, Inc., insights; Stefan Beck, Marita Sturken, and Gisela Welz for comments; and the World of Coca-Cola, Atlanta, for unwitting assistance.

1. *SpoilSport's Guide to the Olympic Games* (Atlanta: Empty the Shelters, 1996).

2. I have adapted these terms from J. Johnson (aka Bruno Latour), "Mixing Humans and Nonhumans Together: The Sociology of a Door-Closer," *Social Problems* 35, no. 3 (June 1988): 298–310.

3. Abu-Lughod, in conversation with author, and Ulf Hannerz, *Cultural Complexity: Studies in the Social Organization of Meaning* (New York: Columbia University Press, 1992).

4. Arjun Appadurai, "Disjuncture and Difference in the Global Cultural Economy," *Public Culture* 2, no. 2 (Spring 1990): 1–24.

5. Michel de Certeau, *The Practice of Everyday Life* (Berkeley and Los Angeles: University of California Press, 1984).

6. Arthur Asa Berger, *Reading Matter: Multidisciplinary Perspectives on Material Culture* (New Brunswick, N.J.: Transaction Publishers, 1992), p. 24.

7. Then owner Asa G. Candler, reported in company literature.

8. Mark Pendergrast, *For God, Country, and Coca-Cola: The Unauthorized History of the Great American Soft Drink and the Company That Makes It* (New York: Scribner's, 1993).

9. C. Gilborn, quoted in Berger, *Reading Matter*, p. 24.

10. Frederick Allen, *Secret Formula: How Brilliant Marketing and Relentless Salesmanship Made Coca-Cola the Best-Known Product in the World* (New York: Harper Business, 1994).

11. Pendergrast, *For God, Country, and Coca-Cola*, p. 18.

12. Henry J. Frundt, *Refreshing Pauses: Coca-Cola and Human Rights in Guatemala* (New York: Praeger, 1987).

13. Jeffrey Ballinger, "The New Free-Trade Heel: Nike's Profits Jump on the Back of Asian Workers," *Harper's*, August 1992, pp. 46–47.

14. Mary White, "Improving the Welfare of Women Factory Workers: Lessons from Indonesia," *International Labor Review* 129, no. 1 (1990): 121–133. Also see Global Exchange, "Report on Nike," *San Francisco Global Exchange*, 16 September 1996.

15. Mark Clifford, "Spring in Their Step," *Far Eastern Economic Review* (November 1992): 56–60.

16. Hoover Company database.

17. Kobena Mercer, *Welcome to the Jungle: New Positions in Black Cultural Studies* (London: Routledge, 1994), p. 138.

18. J. B. Strasser and Laurie Becklund, *Swoosh: The Unauthorized Story of Nike and the Men Who Played There* (New York: Harcourt Brace Jovanovich, 1991), p. 623.

19. R. Williams, *Reading Rodney King/Reading Urban Uprising*, ed. Rhonda M. Gooding-Williams (London: Routledge, 1993), pp. 82–96.

20. Rick Telander, "Your Sneakers or Your Life," *Sports Illustrated*, 14 May 1990, pp. 36–49.

21. C. L. Cole and A. Hribar, "Celebrity Feminism: Nike Style Post-Fordism, Transcendence, and Consumer Power," *Sociology of Sport Journal* 12, no. 4 (1995): 327–369.

22. Kleya Forte-Escamilla, *The Storyteller with Nike Airs, and Other Barrio Stories* (San Francisco: Aunte Lute Books, 1994), pp. 53–65.
23. George Lipsitz, *Dangerous Crossroads: Popular Music, Postmodernism, and the Poetics of Place* (London: Verso, 1994), p. 24.
24. Ibid., p. 36.
25. Mel van Elteren, *Imagining America: Dutch Youth and Its Sense of Place* (Tilburgh, Netherlands: Tilburgh University Press, 1994), p. 200.
26. Quoted in Jay Cocks, "Rap around the Globe," *Time*, 19 October 1992, pp. 70–71.

Opining on Icons Chee Pearlman

Illustrations by Maira Kalman

To

confront

icons

is

to

face

the

subjective.

Who's

to

say

what

is

or

is

not

an

icon

of

our

culture,

our

times,

our

pre-millennial

moment?

Well, in a sense, anyone.

For while the architecture and design curator of the San Francisco Museum of Modern Art has analyzed the current landscape and painstakingly identified twelve magnets of meaning as the centerpiece of his exhibition, an icon's true significance is of course dependent on one's personal experience of it. Or, to repurpose a cliché, that which is iconic is in the eye of the beholder—you and me, the icon makers. Icons are every person's property, and it is thus every individual's prerogative to elevate or deflate them as he or she chooses.

That's the principle anyway. But as we all know, in reality there are huge corporate forces at work behind almost all cultural production that reaches critical mass. This may sound like a conspiracy, but it's not—it's just the way capitalism works. Hip-hop street style gets appropriated and packaged for consumption by suburban youth. The lowly denim jeans, once a working-class staple, are seized on by the titans of fashion. And the Internet, after twenty-five years of obscurity in the hands of the government, academics, and geeks, is now the darling of Madison Avenue, with every self-respecting marketing enterprise sporting its own "http://www" as a badge of cool.

My personal prize for the most unerringly effectual of today's icons goes to the Nike Swoosh. Hundreds of thousands of people walk around serving as voluntary poster boards for this product. They (along with an aggressive marketing campaign) have transformed the design of an art student named Carolyn Davidson—an oddly shaped mark without any blatant connection to its maker—into a hard-hitting mnemonic. Now that the Nike Swoosh has become untethered from the company name, it floats freely—and triumphantly—on shoes, caps, T-shirts, jackets, cups, tote bags, etc., etc. It is symbol as icon par excellence.

In search of a broader read on the state of icons in America, I decided to ask the opinion of designers and icon makers in the cultural realm. The subject, it turns out, is a provocative one, on which anyone seems to want to pontificate. Herewith my respondents readily speak their minds.

p a r t 1

What do you consider iconic in your profession or field of expertise?

What makes your choice

an icon

and how has it achieved this

status?

Paola Antonelli, associate curator of design,

The Museum of Modern Art, New York

Icons are the true expressions of democracy: only the masses can elevate objects to icons. Here are just a few examples of cultural icons today: the Bic pen or lighter; the Volkswagen Beetle; the Converse All-Stars shoes; the "I ♥ NY" sign by Milton Glaser; the Boeing 747; the London Underground logo; the American flag.

Paola Antonelli: the Bic pen

Ralph Caplan, author and director of the

"Center for Peripheral Studies"

The Brooklyn Bridge is as good an example of an icon as any. It represents technological triumph, lyrical sweep, the persistence of engineers, the joining of two municipal boroughs, the reconstruction of American dreams in urban terms. It has achieved this status through the drama of its construction, the routine of traffic over time, and through scores of paintings and photographs and the poetry of Hart Crane.

Jay Chiat, "ex-advertising icon"

The Internet. In less than five years it has caused a paradigm shift in the way people communicate and transmit information, having enormous impact on most commercial and social institutions.

Philip Glass, composer

James Taylor and Bob Dylan are icons in my field, because their styles are instantaneously and universally recognizable. But since style relies on an element of misperception, it misleads you about what is essential about a person or a thing. Thus the public perception of icons like Taylor or Dylan is by necessity fairly removed from the original.

Bob Greenberg, "new media wizard"

In my profession, I would have to say that MTV has defined—or even spawned—an entire generation and is therefore the ultimate Gen-X icon.

Penn Jillette, "more than half (by weight)" of Penn & Teller, iconoclastic magicians

It's a sad thing, but in my "area of expertise," the icon is a top hat and a bunny. When you see a top hat with a bunny, you see everything that makes stage magic insulting and boring.

These objects have achieved their status through stupidity. Magicians used to dress in Merlin robes, but [Jean-Eugène] Robert-Houdin (that's where Houdini got the name) got the idea to dress just like the audience. He dressed in top hat and tails, which is what the English in the nineteenth century wore to the theater. A lot of technology was developed for hiding junk in that clothing, and then magicians were too stupid to realize that audiences no longer dressed like that. As far as the rabbit is concerned, people love to see livestock: look at Siegfried and Roy.

Tibor Kalman, designer and editor

What's iconic in the design profession is an 8 1/2-by-11-inch sheet of paper and a number 2 pencil. Everything else is secondary—it's perfume as opposed to substance. But actually, in a design office, the most important icon is a crumpled

Tibor Kalman: a garbage can

piece of paper, and the most important tool is a garbage can. I recommend Rubbermaid—in black, of course.

Jon Lomberg, artist and designer of interplanetary, interspecies messages to Mars, the galaxy, and the far future

The nuclear weapon evokes our deepest nightmares about technology and the human capacity for evil and stupidity. Many other images (oil-soaked birds, polluted skylines, starving children) conjure up human evil in an iconic way, but almost none so universally and powerfully as the mushroom cloud.

Ross Lovegrove, British designer

The Concorde. This plane is an Anglo-French phenomenon that I view every day from my terrace at approximately 4:25 P.M. as it arrives from New York. I always stop what I'm doing, and stare, almost honoring it with a moment's silence for its startling technological beauty. This is an old design that retains its status as the apex of civil aviation. It is incomparable. It is incredibly sensual, and even the sound of its magnificent engines heralds its presence. It is high technology but at the same time manifests itself every time a child—from the Sudan to Jakarta—folds a piece of white paper to make an airplane.

74

Paul Lukas, columnist and author of "Inconspicuous Consumption: An Obsessive Look at the Stuff We Take for Granted"

The Brannock Device foot-measuring gizmo, named after its inventor, the late Charles F. Brannock. My area of obsession is what I call "inconspicuous consumption," and the Brannock Device is classically, quintessentially, prototypically inconspicuous—everyone knows what it is (try to find someone whose feet haven't come into contact with one—can't be done) but nobody knows what it's called. Make no mistake, it is an icon—it's been a factor in everyone's life, after all—but nobody thinks about it. Call it an inconspicuous icon.

Murray Moss, entrepreneur, proprietor of the Moss store

The lightbulb is my "Rosebud." In a cartoon, it's what one draws over someone's head as a metaphor for having a sudden, clear idea; in this instance, it is pure iconic association. Ingo Maurer, in his Pop art "Bulb" lamp of 1965, designed a clear glass bulb-shaped "shade" to sit over the actual illuminated bulb within, illustrating perfectly the redundancy of further concealing this well-designed object.

Phil Patton, author and design journalist

For me one of our recent cultural icons is the face—with almond eyes and big head—of the classic gray alien. Its overtones are of a hungry child, with big Keene eyes and a head larger than the body. It represents a new stage in the complex folkloric history of the UFO subculture: the face has become as much a graphic cliché as Sambo or Uncle Tom. The gray face distills many legends and lies, drawing together a wealth of media material into an image like the fairy face or werewolf of past cultures.

Phil Patton: the classic gray alien

Alice Rawsthorn, correspondent for the "Financial Times of London"

An icon of my professional life is my car, a 1994 Renault Twingo, because it has redefined car design. It was conceived by Renault as a *voiture de jouet,* literally a "toy car," with a deliberately jokey aesthetic that both is endearing and debunks the archaic notion of the car as a materialistic totem, a testosterone-charged symbol of the owner's economic and social status. Instead, the Twingo is self-effacingly small, making it easy to drive and to park. It marked a radical shift in Renault's approach to product development, as, instead of devising a car that a majority of consumers would like, the company created one that a minority of people would love so much they felt they had to buy one, which makes perfect sense in an age of saturated consumer markets.

Karen Stein, senior editor, "Architectural Record"

Corbusier's glasses. The reason they are iconic is self-evident.

John Thackara, director of the Netherlands Design Institute, Amsterdam

A blank sheet of paper. It's a carrier of meaning which, in its emptiness, demands an action and thereby provokes interaction.

Karen Stein: Corbusier's glasses

p a r t 2

Curator Aaron Betsky of the San Francisco Museum of Modern Art

has identified a core list of icons for the show

"Icons : Magnets of Meaning."

What do you personally consider iconic of American culture today?

Any

favorites

?

Paola Antonelli

As a non-American, I can assure you that the Stars and Stripes are still the paragon of all American icons. An icon is by definition visual, and its universality lies in its recognizability. The flag is the visual symbol of American culture, as all Americans recognize themselves in it and as it is recognizable by everybody all around the world.

Ralph Caplan

Coke bottle. Jeans. Muhammad Ali. Golden Arches. Casablanca ceiling fan. Mickey Mouse. Eames chairs. White sliced bread, which perfectly represents the union of sterility and utility. Only a culture committed to convenience at any cost would so willingly have sacrificed flavor to standardization.

Jay Chiat

McDonald's Golden Arches. It has neutralized the American palate. My personal favorite cultural icon is the architect Frank Gehry.

Stewart Ewen, author and professor of communications at Hunter College, New York

The most omnipresent American icon today is the UPC bar-code symbol, attached to nearly everything. Beyond its data utility, the UPC's ubiquity—its boundless territorialism—speaks to the near total triumph of market values. All objects are branded and unified by their commodity status. As placed in my design for a new American flag, the UPC speaks to the ways that pecuniary values and the trajectory of national culture are, more than ever before, indistinguishable. Not only will this be the new flag; the country, itself, will be renamed: United Markets of America (U.M.A.).

The denial symbol is another paradigmatic icon of our times. Seen everywhere in red, applied to all imaginable acts, it embodies an ethos of universal prohibition that lies right beneath the surface of a culture ostensibly committed to the gratification of individual desires. It is the perpetual *"DON'T!"* that chastens our behavior at every turn. (Is there an icon for *"Do!"*?)

Bob Greenberg

In American culture today, the other icons I see around me are:

The Statue of Liberty. It's so overused as an icon for America and American values that we can't seem to get that hunk of metal we used many projects ago out of the studio. I'd instantly recognize a close-up of even a point on her crown.

The Jeep. It's the ultimate '90s vehicle. The car industry is vast—and no other aspect of it is growing as quickly as the off-the-road vehicle segment. That's pretty big.

FedEx. FedEx has become synonymous for mail. Now you never say, "I'll mail it." It's always, "I'll FedEx it."

MasterCard. Those interlocking red and orange orbs have taken over the globe.

AT&T. What other logo is bigger than Nike's?

Windows '95. Talk about ubiquitous.

Netscape. Ditto.

The International "No" Symbol. This symbol has unique power since it begs the universal question, What part of 'no' don't you understand?

I'd have to say that one of my favorite American cultural icons is the ad with Ralph Lauren on a horse. There's something you gotta love about this American-Jewish guy in this classic equestrian pose—as the ultimate representative of a uniquely New World aesthetic stitched together from the trappings—everything from the country manor to the safari—of old money, Old World WASP culture. You can only admire the flair, not to say chutzpah.

Penn Jillette

An electric guitar (Fender Strat, or Gibson Les Paul). It's the opposite of a top hat and a bunny. My favorite cultural icon is a monkey smoking a cigarette. It's the perfect icon for everything funny.

Tibor Kalman

There are two icons that offer a lesson in contrasts. One is the basic, absolutely undesigned Kiehl's packaging, and the other is the Nike Swoosh. Both accomplish the same thing but with completely different strategies and intent. As for a favorite American icon, I choose Bart Simpson.

Jon Lomberg

The really big American cultural icons? Trash: well-packaged, hi-tech, hugely popular trash.

Ken Love, creative director of Lippencott & Margulies, identity consultants

Since its inception, the dollar bill has been the most honest representation of American culture. It's a ubiquitous icon of what drives this country. It's not called "the almighty dollar" for nothing. The credit card, however, is providing strong competition for replacing the greenback as America's cultural icon.

Ross Lovegrove

The American Express card, because its design is symbolic of currency. It represents not only monetary but cultural exchange. A favorite? Absolutely! The Sapporo beer can, for any number of reasons.

Paul Lukas

Icons used to reflect some sort of commonality throughout a given culture, but today's icons are bought, not made. The Nike Swoosh, for example, is every-where, and we've all become familiar with it, even though many of us (myself, for example) have never owned a single article of Nike footwear or clothing. Why? Primarily because of advertising, which communicates and signifies on a much larger scale today than ever before. As media expands throughout our society and intermingles with other parts of our culture, this trend will only intensify.

Katherine McCoy, educator and graphic designer

Some icons, or cultural symbols, that readily come to mind include:

Ross Lovegrove: the American Express card

Barbie dolls, Mickey Mouse ears, baseball cap, white T-shirt, VW, Harley-David-son, Nike shoes, long-necked beer bottle, pickup truck, skateboard, 747, Statue of Liberty, diamond ring, styrofoam cup, the Dreyfus telephone.

I think it is difficult to identify any cultural symbol that carries identical mean-ings across our increasingly differentiated society. We are no longer a mass soci-ety. The America of the 1950s is splintering into more and more balkanized, highly defined subcultures. So one subculture's icon will be meaningless for the next.

On the other hand, *everything* now seems to be an icon (i.e., cultural symbol) to someone. Everything is a cultural construct with an agenda. Our postmodern sensibility reads meaning into everything, so our every mark and every move car-ries encoded significance that someone will be ready to interpret.

Murray Moss

Images of the American flag, of that particular layout of stars and colored stripes. It is there so that we can all appropriate it for our personal use. With it, we honor the dead, we open a dry cleaners, we mail a letter. We wave it in protest, we wave it in support. It welcomes us home when we return from overseas. It was created to be the perfect metaphor for each of our personal utopias.

Ettore Sottsass said design is a way of discussing life. I like his red Valentine typewriter. In 1969 it willfully appropriated an existing icon and instantly changed all our associations with it. Now we see politics and eroticism where before there was a dry office chore. It's even decorative.

Alice Rawsthorn

My favorite cultural icon is John Lennon, because when I was a child growing up in Britain in the 1960s and early 1970s, he proved that it was possible to break free from the conventions.

Karen Stein

Remote controls are the icons of today's culture, for reasons that are self-evident.

John Thackara

Manhattan's grid: the myth "made concrete" of reason prevailing over nature.

My favorite icon? Manhattan, because although we can't manage nature, neither can we leave it be. There's no turning back.

Robert Venturi, architect and author

The Golden Arches that create an *M,* the ultimate populist symbol that started life as '50s structural elements and became a worldwide symbol of the U.S.A.

Lorraine Wild, graphic designer and educator

The color black. The absence of color—black—adds the most powerfully complex meaning of all. The black cape, the black sunglasses, the black leather jacket, the little black dress, the black label on a bottle of Scotch, the black box of an airliner, the black Stealth bomber, the black weapon, the black death (not just plain old beige death). What other color covers such a range of associations? I think that makes it an icon.

p a r t 3

With so much explicit material in our visual environment, do

you believe it is possible to create objects or images that are

iconoclastic?

What have you experienced recently that you would consider

iconoclastic?

Paola Antonelli

As long as there are icons, they can be broken. Tibor Kalman's *Colors* magazine and the "Howard Stern Show" have both, each in its own way, shattered certain icons.

Ralph Caplan

Of course it's possible to produce iconoclasm. "Clasting icons," as Gary Wills puts it, are more common than ever. Flags are burned, heroes exposed as frauds. Even mother's milk is assailed, if drunk in public. The most literal iconoclasm I know was the smashing of Coke bottles by students under the direction of then Sister Mary Corita at Immaculate Heart College. Now that the making of icons is a public industry, their shelf life is less secure than ever.

As for recent examples, the prestige of Great Britain's royal family has been laid low by media iconoclasm, with the colluding support of the Crown's own lack of taste and judgment.

Bob Greenberg

There is no symbol of the twentieth century as iconoclastic or as brilliantly terrifying and dreadfully enduring as the Nazi swastika. It still strikes fear into the heart, and probably always will. I guess this means that there will always be an opportunity to create (or even, as in the case of the swastika, repurpose) lasting symbols that break the mold—for good or evil.

Penn Jillette

Sure it's possible to create something iconoclastic—you can still burn a flag or turn a cross upside down—you might get beat up or go to jail, but it works. As for our little tempest in a top hat in our corner of the universe of magic, when Teller tosses a live rabbit into a chipper/shredder, that seems to get our iconoclastic point across just fine.

Tibor Kalman

Bart Simpson. See previous question.

Jon Lomberg

Skeptical and rigorous thinking of any kind is so unfashionable as to be iconoclastic whenever it occurs. A journalist like the late I. F. Stone is far more iconoclastic than Madonna's book *Sex*.

Ross Lovegrove

A perfect PET plastic cup handed out by the thousands on airplanes every day and then immediately discarded.

Paul Lukas

Anyone with enough money can gain sufficient media access to create an icon in today's information environment. Just buy up enough time on TV, and boom!—you've created something that millions of people will see. Show it to them often enough (and, of course, creatively enough) and you can create an iconic association in people's minds. This isn't how it used to work—icons used to *happen,* through a series of causes and effects that were much harder to predict or anticipate in a pre-mass-media age. Icons used to reflect society's direction; now icons direct society.

Katherine McCoy

Think how quickly symbols shift in the media these days. An American flag on a car bumper in the early 1970s meant a political conservative who supported the Vietnam War, and I steered clear. Now that the Freemen and militia types have demonized the federal government, I find I greet that same decal with some relief. The same goes for "Support Your Local Police," now that the police are supposed to be jackbooted thugs.

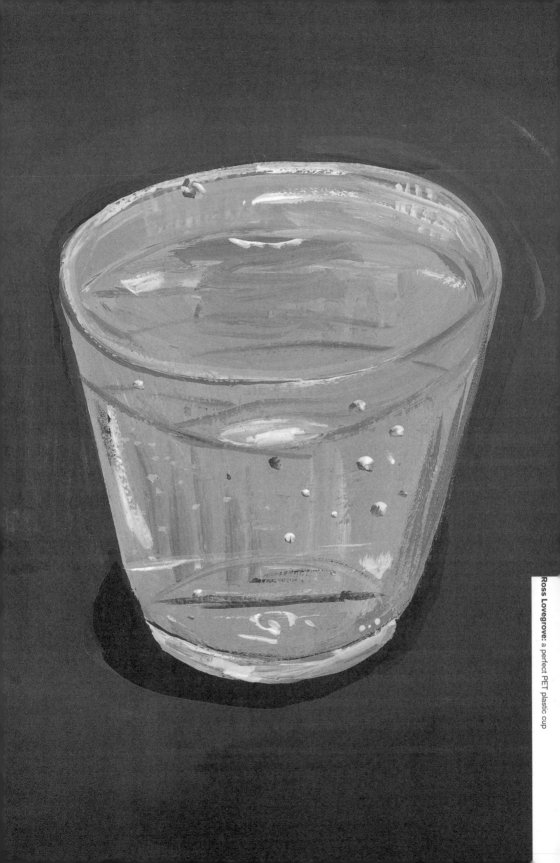

Ross Lovegrove: a perfect PET plastic cup

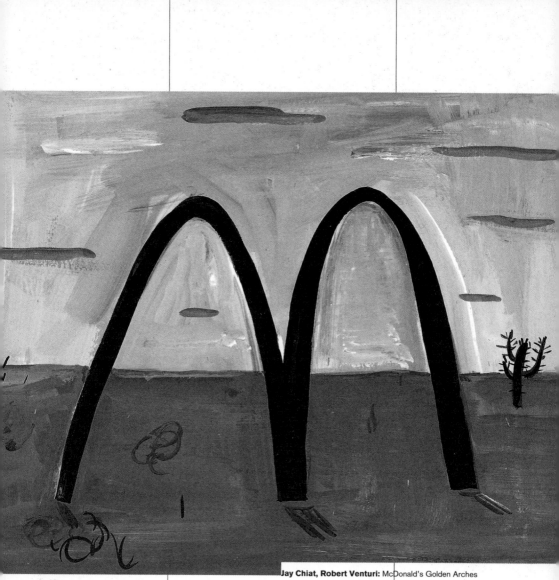

Jay Chiat, Robert Venturi: McDonald's Golden Arches

90

Isaac Mizrahi, fashion designer

With so much fodder in popular culture today, I can no longer distinguish between icons and iconoclasts. Icons are dead. Whether to mourn or cheer is up to the individual. Personally, I do both. I keep complaining that I was born two centuries too late—and in the very same breath, exalt the time I live in as the most exciting in history. So go figure.

Alice Rawsthorn

Intensive exposure of an icon does not diminish its significance. And, if one accepts that a characteristic of an icon is its ability to reflect the moment, then, by definition, it will be able to transcend the media clutter.

John Thackara

Yes, it is possible to create something iconoclastic. Give everyone a pocket mirror to look at themselves with. It's better and scarier than TV.

Robert Venturi

Any iconoclastic symbol repeated often enough equals an icon. An example? McDonald's Golden Arches.

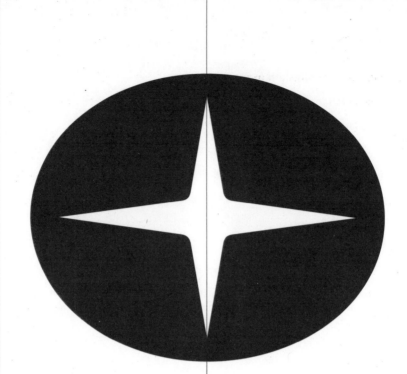

The Cultural and Historical Roots of American Icons

David E. Nye

The term *icon* has acquired many connotations. In art history it refers to religious portraits, in semiotics to a category in Charles Peirce's system, in studies of mass culture to charismatic figures, and in communications to a sign on a computer screen, such as @. Rather than use this limited space on an archaeology of this complex term and the closely related *iconography,* I will work outward from the twelve icons at the center of this exhibition, which focuses on popular objects rather than famous or religious figures. Such icons embody a cultural shorthand more concrete than symbols and less explicit than written text. They seem to resist the flow of time, and yet they are products of a particular historical moment.

Minicams, @, corporate logos, automobiles, electrical gadgets, and surfboards are

icons of postindustrial capitalism in what may be its last great efflorescence of consumerism. However long this stage lasts (its limits may well be set by what the global ecology can support), it is a distinctive epoch, which the icons displayed here may well come to represent.

The logo of an international bank may seem to have little to do with a baseball bat, an art museum building, or a pair of jeans, but these are parts of an international system of symbolic and economic exchange. Icons are privileged nodal points in the endless semiosis of modern culture which provide the illusion of stability. These are not symbols but fusions of materiality and meaning through the praxis of design. The substances found in a surfboard, portable computer, microwave oven, or minicam are often made from new materials, such as plastics or new metal alloys. In contrast to artifacts of earlier times, most people do not understand the physical nature of the objects around them, and we almost never are able to repair a broken part. Rather, we apprehend them as disposable forms that make it easier to surf the waves, the Internet, the landscape, or the highway. What are the cultural and historical roots of these icons? There are many ways to tell this story, but let us begin with the movement from hallmark to trademark to icon.

Although silversmiths and other skilled workmen had long put an inconspicuous hallmark on their productions, these were not registered and protected like trademarks, which were permitted by federal law after 1881.[1] The creation of such trademarks went hand-in-hand with the expansion of corporations to serve the national market and the development of national advertising, distinctive packaging, and brand names, all of which made a particular product readily identifiable to the consumer. Trademarks were often made into corporate logos, sometimes simply in the form of elegant writing (General Electric, Ford, Coca-Cola), but more often as a fusion of written and visual imagery (Sunoco, Zenith, Texaco, NBC).[2] These compressions of corporate identity were especially well suited to electrified advertising, and they studded the Great White Ways of American cities, beginning around 1900

with the erection of a giant green Heinz Pickle in Madison Square, New York, and quickly extending up to Times Square. By 1910 more than twenty blocks of Broadway were covered with signs that cost hundreds of thousands of dollars apiece, and these collectively created a new landscape that was an international tourist attraction.[3] Corporations soon realized that such displays were not suited to presenting an argument or substantial bodies of text, but rather to keeping a brand name and a logo before the public. As an advertising handbook for salesmen explained, "The story is told in detail in magazines and newspapers, and the spectacular electric sign follows with its flashing presentation of the trademark."[4] Television and later the computer made it possible to miniaturize the electric landscape and bring it into the home. The brand names and trademarks once represented in Times Square now flash across the screen, achieving name and logo recognition through endless repetition.

As the means of representation improved, the trademark began to serve a new function. At first it had been intended as a recognizable marking, which assured buyers that a particular good or line of goods came from a familiar source. Trademarks were jealously guarded, because infringement jeopardized a product's identity and interfered with the creation of customer loyalty. Often the trademark was not only put on a package but stamped on the surface of the product as well; examples include the Louisville Slugger and Nabisco cookies. Soon a process of amalgamation began, so that the trademark was not merely on the surface but began to fuse with the

object. Coca-Cola bottles are a good example. They emerged as distinctive containers whose form immediately announced their contents. The Coke bottle was more than a guarantee of origins; it was advertisement, trademark, and product, rolled into one. As the national market developed, packaging began to be more than merely a practical necessity and was integrated into marketing.

At the same time, product design gradually became more important. As production methods assured reasonably high levels of performance, the consumer increasingly selected goods less on functionalist criteria than on more intangible standards of taste. Especially during the Depression era new products had to be attractive, safe, and easy to use. Styling distinguished one brand from another, and new visual vocabularies, such as streamlining, were introduced.[5] Even before industrial design had matured, advertising began to emphasize the increased "reality" of improved products. Miles Orvell found that after 1900 "one

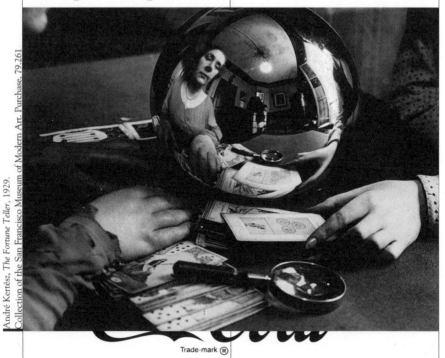

Trade-mark ®

repeatedly encounters products that offer themselves as some more intense experience of themselves, a more emphatic, more real version of their virtues."[6] Thus Hires Root Beer was extolled because it had "real Root Juices," and Vermont maple syrup had "real Maple Sugar Flavor." Orvell continues: "It was as if there were some defect in everyday reality that had to be remedied by the more authentic reality of the object to be consumed."[7] Products that successfully laid claim to this heightened reality became icons; they epitomized a more perfect world and served as an industrial version of Platonic forms. The public was repeatedly urged to own these "real" things as accoutrements of a better self. At all levels of society Americans became obsessed with authenticity, paradoxically desiring both the genuine and the new, determined to possess "the real thing." Yet the very process of endlessly substituting new goods for old made yesterday's "real" obsolescent.

The new icons reversed the defamiliarization that was a common strategy of revolutionary art in the early decades of the twentieth century, and particularly widespread in the 1930s. Defamiliarization asks the artist to see the world afresh by "making strange" an everyday reality encrusted with banality. The notion underlying this aesthetic, as Simon Watney has pointed out, was that the organs of perception were "all-conditioning portals of knowledge" that could be "cleansed of the mystifying and misleading accretions which result from our experience of a corrupt and corrupting world."[8] Emerson, Thoreau, and Whitman were American precursors of such ways of thinking. They urged the architect, the poet, and the artist to "make it new." In the twentieth century Man Ray and other photographers developed such ideas and sought to "make strange" their subjects through the use of odd angles, mirrors, extreme close-ups, distorted shadows, juxtapositions, and collage.

If defamiliarization was a central idea in modernism, however, corporations sought just the opposite. They wished to represent products that really were new as

Julia Margaret Cameron, *Queen Phillipa Interceding for the Burghers of Calais*, ca. 1865. Collection of the Yale University Art Gallery. Director's Discretionary Fund

though they had been around for decades. General Electric designed its first appliances and lighting fixtures so they fit seamlessly into a Victorian home. They were not presented as cutting-edge technologies that would wire the house to an electrical network, but as new versions of convenient, familiar devices.[9] For advertisers, a common method of doing this was to insert a new object into what Roland Marchand has called a social tableau, a somewhat idealized "slice of life" that is "sufficiently stereotypical to bring immediate audience recognition." These tableaux evolved from the *tableaux vivants* in vogue at the end of the nineteenth century, and they also owed much to the American theater. They were not mirrors of society but rather mirrors of aspirations, and they usually depicted "settings at least 'a step up' from the social circumstances of the readers."[10] The new product was inserted into a familiar landscape of objects so that it paradoxically both blended in and stood out. As Jackson Lears has noted, "No matter how fervently they chanted the gospel of newness, advertisers knew they had to establish some common ground, some sense of old-shoe familiarity between the purchaser and the product."[11] The really successful consumer product often seemed extremely familiar—even hyperfamiliar—a word that brings Umberto Eco's "hyperreality" to mind. What the modern corporation wanted was once expressed by a Nissan executive when he demanded "instant heritage." The icon is at once unknown and hyperfamiliar, instantly the center of an ideal tableau.

2

Fredric Jameson and Herbert Marcuse both observed that the artifacts of the older industrialism still preserved traces of physical labor; their human origin had not been entirely effaced. But the products of postindustrial capitalism lack reminders of their human origins and are, one often hears, objects without depth. A quarter century ago Jameson went on, mistakenly, to argue that "their plastic content is totally incapable of serving as a conductor of psychic energy.... All libidinal investment in such objects is precluded from the outset."[12] This may be true of the styrofoam coffee cup or the plastic garbage bag, but clearly it is not true for the surfboard or the high-tech running shoe.

A decade ago the displays in this exhibition still might have been dismissed as effluvia of "late capitalism" and its culture of consumption. Today it is socialism that looks very late indeed, and the culture of consumption seems a more complex phenomenon than it once did. The neo-Marxist critique held that consumer goods are a concretization of false consciousness. A historical sketch of the argument would emphasize the elements needed to create commercial icons. Mass production was developed in the nineteenth century and reached an early culmination in Henry Ford's assembly line of the 1910s. To sell these goods, national advertising was fully developed by the 1920s, followed by industrial design in the 1930s. As these engines of production and publicity were linked more securely together, the creation of something like icons became the conscious goal of manufacturers. In the 1970s Stuart Ewen argued for this scenario in *Captains of Consciousness*, contending that welfare capitalism alone did not bring workers to accept the new factory regimentation, but required as a necessary corollary a flood of mass-produced goods.[13] According to this position, as corporations shortened the workday, they fostered a mass market and "colonized" leisure. Just as corporations employed engineers and elec-

trified production to gain control of factories, so they used advertising, industrial design, marketing, and public relations to gain control over leisure and the domestic system of production.[14]

Such arguments assumed that consumers were (and are) passive and easily manipulated and paid little attention to the new goods themselves.[15] It was not so simple. As Jameson soon realized, the products embraced by popular culture often served a utopian function. The consumer was actively seeking release, not passively imbibing ideology. This approach holds that popular culture contains within it longings that are subversive of the status quo. Popular amusements could be understood not simply as forms of false consciousness but as a necessary psychic release from the world of work, expressing yearnings for a different life.[16] An academic industry grew up examining rock music, romance novels, television programs, films, and other elements of popular culture and showed that rather than imposing a false consciousness on the consumer, they afforded ordinary people the opportunity for release from work routines. Even though these utopian escapes were internally contradictory, and even though they usually recontained the critique implied within them, they nevertheless expressed dissatisfaction with the capitalist order.

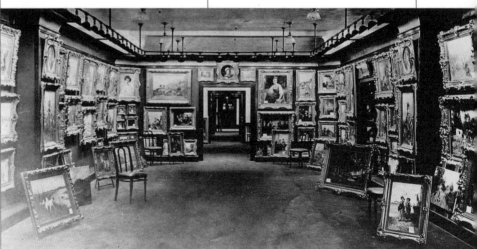

William Leach applied this insight to the department store and found that as early as 1900 it offered female shoppers a safe space for release from domestic confinements, parsimony, and Victorian codes of behavior. Goods were displayed as parts of larger motifs and tableaux, creating a fantastic interior, often embellished by exhibitions of modern art. Before 1920 Gimbels displayed original work by Cézanne, Picasso, and Braque; in Chicago, Carson, Pirie, Scott hung paintings by the Ash Can School in its store gallery. The department store was the palace of consumption, making shopping pleasurable, even theatrical, as the well-dressed crowds gazed at the chandeliers, rode in the new elevators, or looked at each other, measuring their position.[17] Products began to become icons, as shopping became a never-ending act of negotiation between the self and a dazzling world of transformations. Consumption on the elaborate stage of the department store seemed to offer both a cornucopia and a liberation from care and toil. In these years Thorstein Veblen coined the term *conspicuous consumption* to describe the symbolic uses that consumer goods had achieved, as the middle class learned not merely to display wealth but to act out new social roles. Material goods were building blocks of identity. As the anthropologist Mary Douglas argues, "The most general objective of a consumer can only be to construct an intelligible universe with the goods he chooses."[18]

3

In revising our understanding of the process of consumption, it is not enough to realize that the older critique was mistaken to see the public as passive. The older model also assumed that the culture of consumption emerged along with the corporation, expanded with improvements in transportation, and triumphed as oligopolies moved into marketing domestic goods. In fact, the culture of consumption emerged before American corporate capitalism, in eighteenth-century England or even earlier, and it was driven to a considerable degree by emulative spending and the desire for social distinction. Already in the England of 1750:

What men and women had once hoped to inherit from their parents, they now expected to buy for themselves. What were once bought at the dictate of need, were now bought at the dictate of fashion. What were once bought for life, might now be bought several times over. What were once available only on high days and holidays through the agencies of markets, fairs, and itinerant peddlers were increasingly made available every day but Sunday through the additional agency of an ever-advancing network of shops and shopkeepers. As a result "luxuries" came to be seen as mere "decencies" and "decencies" came to be seen as "necessities." Even "necessities" underwent a dramatic metamorphosis in style, variety, and availability.[19]

In the late eighteenth century, discussion of what we now call the culture of consumption focused on the evils of ostentation and promoted simplicity and efficiency. Benjamin Franklin urged readers of his newspaper and almanac to be frugal and avoid unnecessary outlays. The author of the 1837 *Housekeeper's Book* complained of what would later be labeled conspicuous consumption: "The rage for vieing with our neighbors" which "shows itself in the bad taste by which houses are encumbered with unsuitable furniture." She warned against "massive sideboards, and large unwieldy chairs," "heavy curtains and drapery," the practice of changing the furniture "to suit the varying of fashions," and the occasional practice of buying on credit. She was also dubious about the "newly invented steam kitchens and cooking apparatuses which the last twenty years have produced" and attacked "the inventors of cast-iron kitchens."[20] In 1843 Catherine Beecher issued the most famous of these works on domestic management and household design, *A Treatise on Domestic Economy*. She warned against building on too large a scale: "Double the size of a house and you double the labor of taking care of it."[21] Beecher also complained about excessive ornamentation and proclaimed the duty to establish a Christian home that was comfortable and efficient, not ostentatious. Likewise, Thoreau's *Walden* champi-

oned minimalist consumption and called for a principled simplicity. If we plot the history of icons in this way, then they play a central role in a 150-year retreat from plain living.

Certainly, in the second half of the nineteenth century American houses grew larger and contained more rooms, and these were filled with Victorian furniture, carpets, and heavy drapes, while bric-a-brac covered every middle-class mantel, wall, and tabletop. Certain objects became, if not icons, at least widely recognized emblems of respectability, such as well-upholstered furniture in the front parlor and framed family photographs in prominent positions. One of the most widespread items of conspicuous consumption was the piano, whose presence in the parlor connoted not only a level of wealth but a love of music and culture. One way to conceive the history of icons, then, is to emphasize the rising tide of consumer demands throughout the nineteenth century, countered by calls for principled simplicity. The icon began to be central before mass production and became ubiquitous afterward. Henry Ford was a paradigmatic transitional figure, for he advocated the simple life even as he promoted the assembly line and the automobile, both of which made possible new landscapes of desire. If Ford resisted styling changes, other manufacturers did not; the automobile industry found the public receptive to the idea of annual models. Corporations did not "colonize leisure"; rather, emulative spending and styling "colonized" production. The icon was that product which best ministered to the consumer's needs: elegant yet familiar, timeless yet new.

4

Granting that consumer demand rather than corporate manipulation is central to the culture of consumption, why have consumers preferred to invest themselves in certain objects? Their allure lies in two areas. In the first place, an icon's form appears to transcend variability and time, to become an idealized object. This is so even though we also know that these objects (usually) do not last very long. Not only are con-

sumer goods fragile; the preferred style for any object changes over time. W. J. T. Mitchell goes far toward defining this contradiction within the icon: "The modern fetish, like the image in the camera obscura, is an icon of rational space-time. It is thus declared to be natural magic, a universal convention, in theory 'only a symbol' (thus not a fetish), in practice 'the thing itself' (thus a fetish)."[22] This contradiction is central to the ways that contemporary icons function. To the extent that they are understood as symbols they seem transcendent, but to the extent that they are understood as things, they are subject to the iconoclasm of modernism, which demands that we perpetually make each object anew, so that they succumb to time. The owners of a new icon find that it oscillates between these two states (symbolic and material) until its attraction begins to decay, and the object moves toward obsolescence. Eventually, the object loses its status as an icon, though the speed of this process varies. Discarded, packed away, or resold, it has no symbolic force and is forgotten, except for those few that are resurrected as emblems of a lost era and enter the realm of nostalgia.

As long as it is still being actively used, the iconic object has a second attraction, its kinetic impact, which is arguably its central appeal to the consumer. A Louisville Slugger baseball bat is not merely a pleasing tapering form, but an extension of the arms. It provides particular physical experiences to all those who use it well and know what it feels like to hit a ball in the "sweet spot." Anyone who has played baseball not only sees the bat on display but retains a strong sense of how it feels to heft it and swing it, and an aural memory of what it sounds like. Similarly, the surfboard is not merely seen as a sleek form but felt in the feet and leg muscles as a

sliding, dancing platform. It is ineluctably tied to a particular environment. We know these objects with all of our senses, as dynamic parts of our world. When we see them, we simultaneously imagine their sensory qualities. Likewise, the tail fins on a 1950s automobile were not seen as aesthetic objects but experienced in the high-speed environment of the new interstate highways. The automobile did not merely symbolize mobility; it was used for exploration, self-gratification, and escape. It supplied more power to individual Americans than they had ever controlled before. It displayed personal taste, both through the manufacturer chosen and through added accessories. The psychological investment in the automobile was more than a symbolic flaunting of taste and wealth. Driving extended the senses and empowered the driver in new ways. Don Ihde notes as part of his argument that technology is constantly redefining our lived experience, that the driver learns to sense the car's limits, for example in taking a sharp turn or in parallel parking, so that "one's bodily sense is 'extended' to the parameters of the driver-car 'body.'"[23] Knowing how to drive involves tacit knowledge, which is dynamic and perceptual.

Yet the automobile, unlike the small number of durable goods a person inherited in the preindustrial period, is a transient personal possession that seldom lasts more than a decade and is rarely handed down through the generations. To the extent that the buyer not only invests money in a car but also uses it to expand the parameters of perception, its obsolescence underlines how unstable the sense of identity can be when underwritten by consumption. To lack a car after owning one involves a loss of kinetic contact and a shrinkage of bodily experience.

Because these icons are not merely static representations but dynamic elements with kinetic appeal, the sensory pleasure they bring immediately implies particular styles and forms of living. The icon is a condensation of a possible existence. A lived world is implied by Levi's jeans, a sleek sports car, or an

array of high-tech kitchen appliances. These icons are not foisted upon a passive public; they cater to its desires. As Michael Schudson has forcibly argued, the supposed persuasive power of advertising has been overstated, not least by the industry itself.[24] The Marlboro Man was not originally conceived as a cowboy but assumed many incarnations before it was clear that the public preferred the lone horseman riding through a rugged western landscape. Likewise, the consumer prevailed in demanding more than the solid, reliable, black telephones that AT&T engineers long insisted upon during a virtual monopoly of that industry. The public forced Henry Ford to abandon first the color black for the Model T and then the Model T itself. Consumer desires crystallize around some objects but not others, and despite millions spent on design and advertising, the Ford Edsel car would not sell, the air-conditioned bed never caught on, and many a Hollywood extravaganza died at the box office. Only some products become popular, and fewer still become iconic features of our fantasy life. Advertising alone is not enough. Durability is not enough and often not essential. Walter Benjamin wrote about how the unique work of art lost its aura in the age of mechanical reproduction, but another kind of aura is sometimes attained through mass production. Clearly, it is too easy simply to dismiss the powerful hold these objects have on the imagination as a mere product of clever marketing. To the consumer, a small number of objects have been designed so well that their form, function, and kinetic appeal have fused into a satisfying whole. These icons suggest life worlds. People use them to internalize images and bodily experiences. They embody the landscapes of social life, including aesthetically satisfying museum buildings. Such spaces provide settings to restage the self, and, like the elegant fin-de-siècle department store, they are visited as much for their sensory appeal as for the exhibits that happen to be up at a given time.

The Las Vegas Strip, 1990s

5

Taken as a group, these icons visualize speed, comfort, and frictionless engagement with the world. They manifest the emergence of the consumer's sublime, a new ideological formation that appeared in the postwar period. In the natural sublime, a massive waterfall such as Niagara or a vast space such as the Grand Canyon appears to be too immense for the senses to comprehend. In the consumer's sublime, arrayed in the Mall of America,

Las Vegas, or Disneyland, an immense succession of objects implies an endless multiplication and expansion of bodily experience and life worlds. Where the natural sublime immediately creates a sense of insignificance before the scale and power of nature, the consumer's sublime creates a sense of the impossibility of experiencing all of the man-made sensations on offer. Over several generations Western consumers have become accustomed to the imaginary work of seeing such infinite displays, but I have seen Eastern Europeans stunned by a shopping mall, to the point of being physically ill. The surfeit of objects can create psychic overload, and it is against this welter of objects that icons emerge. For these objects slow down the rush of impressions and offer forms adequate to the desires of the moment, forms that answer both the need for tactile stability and the need to choose among provisional social identities.

The person implied by these objects is not universal but belongs to the wealthiest fifth of the world's population. Young and aspiring to be at least middle class, s/he wants to slice through life in comfortable running shoes, jeans, and T-shirt, cruising in a sports car or surfing the Internet past ideographic landscapes. The self constructed through these icons is comfortable with high technology and has a visual sensibility shaped by the framing devices of television and, more recently, the minicam and computer. Where the nineteenth-century consumer was arrested by the quiet detail of photogra-

phy, this consumer is not content with static representation. This is a gaze embedded in technological structures, which seeks not transcendence but powerful sensations, not stasis but action. This person wants not merely to look at but to enter a landscape, rollerblading, hang-gliding, snowmobiling, driving, or jogging, but not walking. This imagination compresses ideas and attitudes into logos and other forms of cultural shorthand and thinks in terms of speed and immediacy. But the demand for a maximum of experience in a minimum of time tends to undercut the sense of reality contained in any one moment. Experience merges with visualization, and it seems endlessly possible to replay, reprocess, recycle, and reinvent.

Few of these icons belong in the domestic landscape; the implied user is nomadic, like the objects themselves. Locations are temporary, while the portable phone number and the e-mail address remain anchored in cyberspace. Yet no matter how flexible and mobile, this sensibility is subject to the same process of iconoclasm as the objects themselves. Today's icons and the people they imply will become outmoded. The visualizations they privilege will soon seem idiosyncratic and limited. The kinetic engagement with the world they offer will be superseded by other excitements. But for the moment, these icons are central to the construction of a high-tech lifeworld.

Notes

1. Daniel Boorstin, *The Americans: The Democratic Experience* (New York: Vintage Books, 1973), p. 146.

2. See John Mendenhall, *American Trademarks, 1930–1950* (New York: Art Direction Book Company, 1983).

3. On the Great White Way, see David E. Nye, *Electrifying America: Social Meanings of a New Technology* (Cambridge, Mass.: MIT Press, 1990), chap. 2.

4. On electric signs, see David E. Nye, *American Technological Sublime* (Cambridge, Mass.: MIT Press, 1994), pp. 173–198.

5. Jeffrey L. Meikle, *Twentieth-Century Limited: Industrial Design in America, 1925–1939* (Philadelphia: Temple University Press, 1979).

6. Miles Orvell, *The Real Thing: Imitation and Authenticity in American Culture, 1880–1920* (Chapel Hill: University of North Carolina Press, 1989), p. 144.

7. Ibid., p. 145.

8. Simon Watney, "Making Strange: The Shattered Mirror," in *Thinking Photography*, ed. Victor Burgin (London: Macmillan, 1982), p. 173.

9. David E. Nye, *Image Worlds* (Cambridge, Mass.: MIT Press, 1985), pp. 115–123.

10. Roland Marchand, *Advertising the American Dream: Making Way for Modernity, 1920–1940* (Berkeley and Los Angeles: University of California Press, 1985), pp. 165–166.

11. Jackson Lears, *Fables of Abundance: A Cultural History of Advertising in America* (New York: Basic Books, 1994), p. 385.

12. Fredric Jameson, *Marxism and Form* (Princeton, N.J.: Princeton University Press, 1971), p. 105.

13. Stuart Ewen, *Captains of Consciousness: Advertising and the Social Roots of the Consumer Culture* (New York: McGraw-Hill, 1975), pp. 1–26, passim.

14. Such an argument appears in Stanley Aronowitz, *False Promises* (New York: McGraw-Hill, 1973).

15. To conservatives the advent of radio, movies, and other forms of mass-market leisure spelled the death of traditional community. T. S. Eliot lamented that the working classes had lost "traditional culture" and become listless owing to the introduction of cinema, phonographs, and the automobile. Radical critics, notably the Frankfurt School, saw popular culture as a threat from the capitalist class. It took particular interest in the production of popular culture by movie studios, record companies, and television stations. T. S. Eliot, *Notes toward the Definition of Culture* (London: Faber & Faber, 1948), and Martin Jay, *The Dialectical Imagination: A History of the Frankfurt School and the Institute for Social Research, 1923–1950* (London: Heinemann Educational, 1976).

16. Fredric Jameson, "Reification and Utopia in Mass Culture," *Social Text* (Winter 1979): 130–149.

17. William Leach, *Land of Desire: Merchants, Power, and the Rise of a New American Culture* (New York: Pantheon, 1993), pp. 124–150.

18. Mary Douglas and Baron Isherwood, *The World of Goods* (New York: Basic Books, 1979), p. 65.

19. Neil McKendrick, J. H. Plumb, and John Brewer, *The Birth of a Consumer Society: The Commercialization of Eighteenth-Century England* (Bloomington: Indiana University Press, 1982), p. 1. Grant McCracken in *Culture and Consumption* (Bloomington: Indiana University Press, 1990), pp. 3–31, argues that consumption emerged in the Elizabethan period. Holland, Italy, and Spain could also claim to be the first consumer societies, but this is not the place to adjudicate these claims.

20. A Lady [anon.], *The Housekeeper's Book* (1837; reprint, Somersworth: New Hampshire Publishing Company, 1972), pp. 22–23, 43.
21. Quoted in H. Ward Jandl, John A. Burns, and Michael J. Auer, *Yesterday's Houses of Tomorrow* (Washington, D.C.: National Trust for Historic Preservation, 1991), p. 32.
22. W. J. T. Mitchell, *Iconology: Image, Text, Ideology* (Chicago: University of Chicago Press, 1986), p. 196.
23. Don Ihde, *Technology and the Lifeworld: From Garden to Earth* (Bloomington: Indiana University Press, 1990), p. 74.
24. Michael Schudson, *Advertising, the Uneasy Persuasion: Its Dubious Impact on American Society* (New York: Basic Books, 1984).

 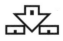

i c ● n s

TEXT BY AARON BETSKY

ICON EMBLEMS BY MARK FOX

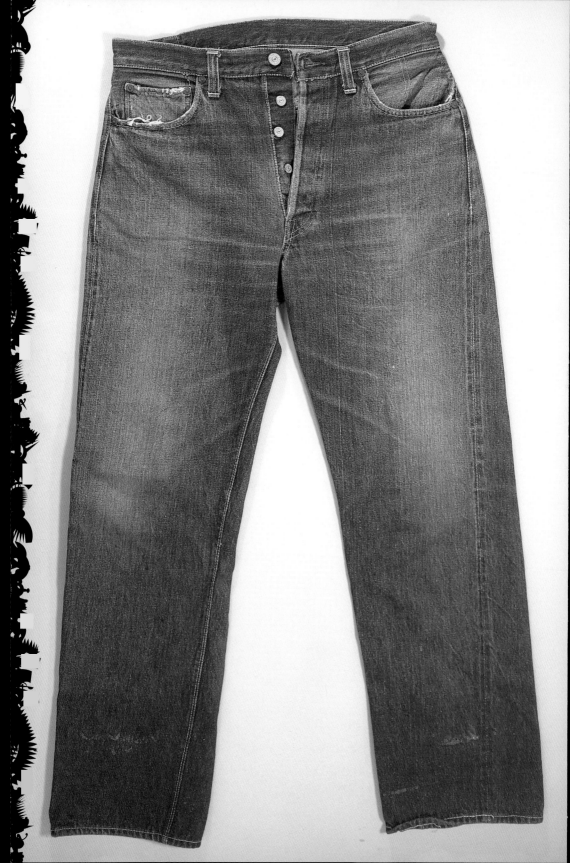

BLUE JEANS

UNIFORMS OF

MODERNISM

A pair of blue jeans is part of the quintessential
American uniform. Whether worn with a T-shirt
or a silk blouse, it is the last vestige of the long
process by which the riches of the western
United States were converted into capital and
then into a culture of consumption. Blue jeans
are work pants that have become marks of
leisure. They now both function as everyday
clothes and evoke the notion of the hard work
for which they were originally designed, becom-
ing the very emblem of leisure and casualness
and embodying a disregard for conventions.
Blue jeans contain these contradictions while
being the simplest pieces of clothing many of us
own, and yet they are also the ones with which
we often have the most associations.

Blue jeans evolved in the late nineteenth cen-
tury as mining pants. They were made out of
denim, a material of French origin (either from
Nîmes, *de Nîmes,* or from southern France,
where there was a material called *nim*). They
took on the name *jean,* which is a slightly dif-
ferent cotton serge but came to refer to a style
or cut popularized by workers in the California
gold mines. Levi Strauss and Jacob Davis
patented the riveted reinforcements in 1873,
and over the next two decades standardized
the shape. Jeans became the favored work

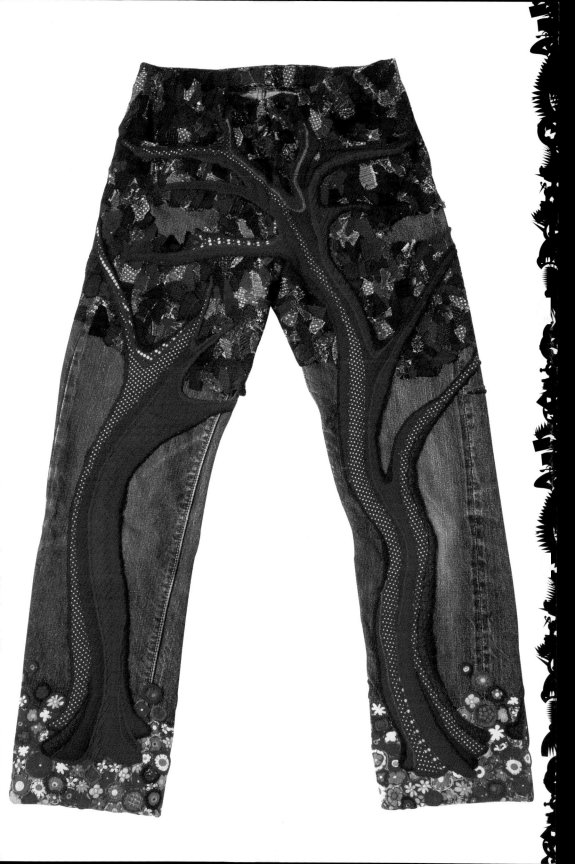

clothes of the west but were no more than adaptations of laborers' clothes that had been in use all over the Western world for at least two centuries.

Western movies popularized blue jeans, along with such related clothes as overalls. After World War II they became the weekend uniforms of suburbanites who thought they were getting back to nature, whether it was as young rebels or mature escapees. In the 1960s hippies embroidered elaborate designs onto worn jeans, thus transforming a mass-produced piece of clothing into a personal statement about identity. The patterns, like the rivets, formed a connection to larger forces through universal patterns. "Hero jackets" (jackets embroidered for a man by a woman) and pants covered with embroidery or patchwork began to dissolve the type into a scaffolding for invention. In the 1970s high fashion appropriated this development, and designer jeans began to take over the market. In the 1980s a return to basics brought with it a renewed interest in Levi's 501 button-fly jeans, and more recently, an exaggeration of the abstract qualities of these pants has revealed itself in the various "loose-fit" versions.

In the century that blue jeans as we know them

top:

POCKET-T, 1996, THE GAP, INC.

Originally an undergarment, the T-shirt has become an all-purpose garment embodying the simplicity and versatility of a uniform while evoking leisure and work at the same time. It conveys a sense of both hygiene and sexuality.

bottom:

PLAIN-FRONT MADISON AVE. KHAKIS, 1996, THE GAP, INC.

As the name indicates, these are upscale khaki pants. Their tailoring does not hide their origins—field pants worn by immigrant Mexican labor. Their name refers to the origin of the material, first used for regimental uniforms in British India.

previous pages:

LEVI'S JEANS AND JACKET, 1973, DECORATED BY HOPETON MORRIS

Studded and fringed, this ensemble elaborates on themes borrowed from both Native American and Indian sources. Here the jeans material

becomes the scaffolding for the construction of a personal mythology.

THE BIG SUIT, 1983, DAVID BYRNE

Byrne, the lead singer for the rock group Talking Heads, wore this suit in performances in the "Stop Making Sense" tour to signal his

transformation from just another body into a media star whose presence is scaled to that of a spectacle.

right:

ZSA ZSA GABOR, FROM THE "LEGENDS IN KHAKIS" CAMPAIGN, 1993, THE GAP, INC.

Seeking to imbue the most ordinary piece of clothing with an aura of celebrity, The Gap unearthed a series of photos of stars wearing khakis. Thus

everyman can be somebody, and somebodies are just like everybody. None of the pants portrayed were sold by The Gap.

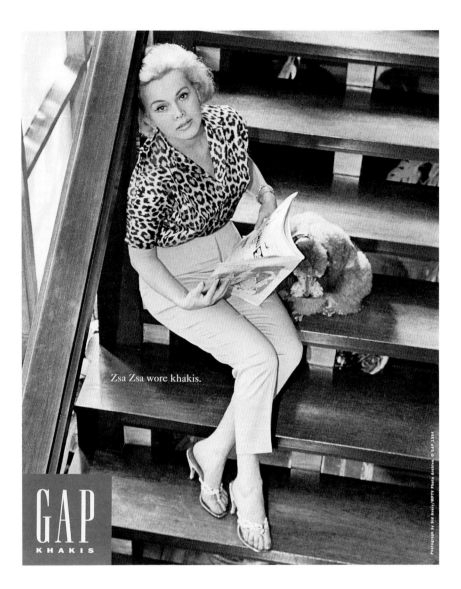

Zsa Zsa wore khakis.

GAP
KHAKIS

have been around, they have remained a canvas on which we can paint (sometimes literally) any kind of association. As such, they are the modern equivalent of a uniform that contains individual personality within an overall identity. They are not alone: chinos, T-shirts, and the businessman's or -woman's suit does much the same. Such uniforms in the twentieth century do not so much mark us as a member of a class or profession as they are a central part of the way each of us constructs an identity for ourselves out of pieces produced for us. We choose our clothes, but only after they are mass-produced for us. It is in choosing and then assembling those selections that we construct our individual appearance.

Blue jeans cover and express, turn us into members of a tribe and hug our body, are generic, simple, and yet expressive. They do not so much exhibit a use or our body as they evoke both while working as the most versatile parts of the complicated wardrobe of our lives.

FELT SUIT, 1970, JOSEPH BEUYS

Beuys claimed that this suit originated in a memory of an episode from World War II, when he was wrapped in felt and animal fat to prevent him from freezing to death. At the same time, this is the gray businessman's suit suddenly imbued with a sense of dense materiality.

top:

THE WEST GREW UP IN LEVI'S, 1950s, LEVI STRAUSS & CO.

The preindustrial west has always provided American culture with images of innocence and freedom, here for sale in its most reduced form as

a pair of pants. This ad dates to the period when westerns were once again popular while more and more of the population was living in a

suburbanized west.

bottom:

THE ROLLING STONES: STICKY FINGERS, 1971, ALBUM DESIGNED BY ANDY WARHOL AND CRAIG BRAUN

The album, which mixes blues, gospel, country, and hard rock influences, found its perfect encapsulation in this image, which concentrates on the

most licentious part of pants that define, rather than drape, the body. The zipper comes down to reveal underwear.

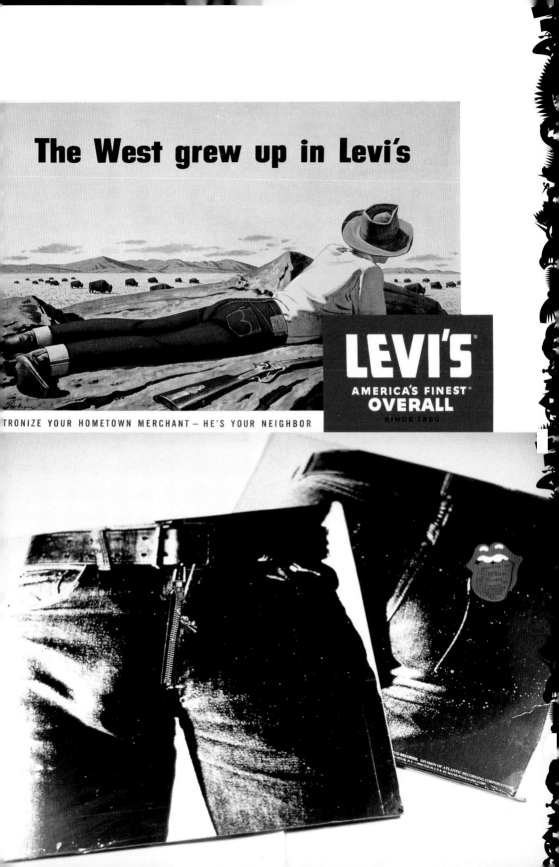

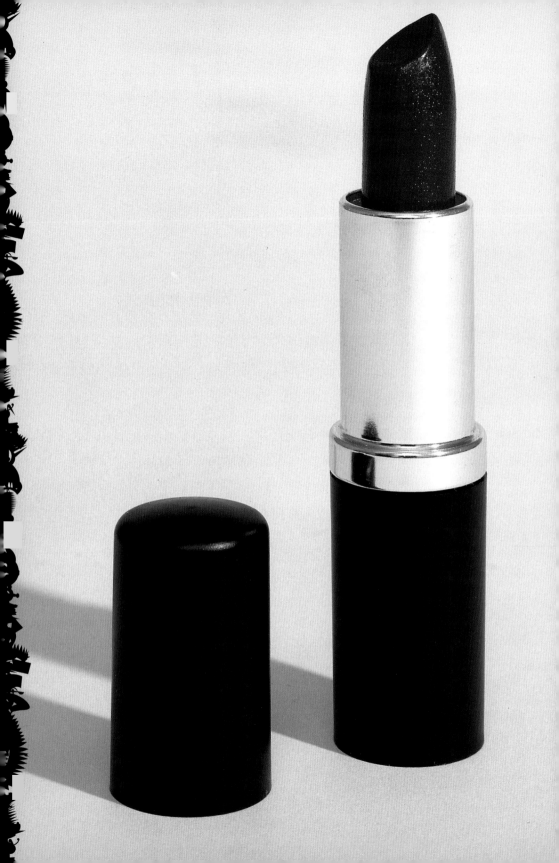

L I P STICK

MASKS OF

BEAUTY

previous pages:

WORD OF MOUTH: PERFECTION, 1996, PHILOSOPHY

Here lipstick has found its perfect embodiment: a black cylinder that opens to reveal a metallic heart pushing up a shaft of pure red. This is an upscale, understated lipstick available in only a few stores.

LASTING COLOR LIPS, 1996, MOLTON BROWN COSMETICS

Here lipstick has become even more abstracted into a metallic cylinder, and the purity of its form makes it more of a self-contained object than the traditional three-part applicator.

right:

COLOR COMPACTS, 1996, H_2O+

Unlike the traditional compact, this variation is translucent, giving a hint of the color and mystery it contains through a covering that recalls both languid liquid and the voyeurism of frosted glass.

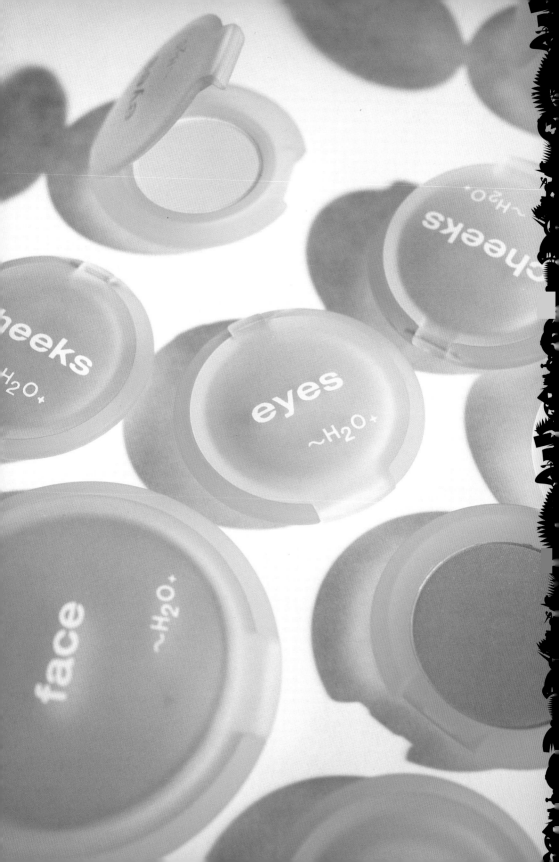

Lipstick exists somewhere between adornment and implement. Strictly speaking, it is both a tool for applying pigment to the lips and the pigment itself, but the lipstick is also an accessory that extends a woman's ability to transform her body through the use of manufactured implements. The lipstick does so, not by adding an artifact, in the way jewelry does, but by emphasizing an existing feature of the face, streamlining and abstracting the lips into the central part of the mask of beauty. Lipstick substitutes what Western culture has constructed as femininity for the individual characteristics of each person. The earliest known examples of the use of lip pigmentation are documented in Egyptian tomb paintings, and over the centuries the methods of applying this color, as well as the forms of the pigment itself, have developed and proliferated in many directions. Lipstick was condensed into the current applicator form at some point in the late nineteenth century, with patents for screw mechanisms being granted as late as 1924. The successive innovations in the pigment and mechanics of the lipstick made what once had been either a mark of aristocracy or for the presentation of the self for sale (either in the theater or on the streets) into a mass-market product.

THE GAP CUBE SOAP, 1991, GARY MCNATTON

Originally designed for Mottura, this soap turns an everyday object into a miniature monument perched on a pedestal of extremely lightweight concrete.

Today's lipstick is a creation of mass produc-
tion, which makes it disposable. The costs of lip-
stick to the consumer come almost wholly from
the immense effort of selling the image of the
product, not from its manufacture. The form has
become standardized, leaving designers only
with logos or fake marks of luxury as the means
of identifying and differentiating their products.
Lipstick shows how a simple, everyday item
such as a pen or a compact can be reduced to a
symmetrical shape with very few moving parts
that can then be sold through an elaborate
mechanism of advertising and propaganda.

The other implements of beauty we use today
have undergone a similar process of simplifica-
tion and fetishization. This is true of the com-
pact, which was once an excuse for ornamenta-
tion in silver and gold and is now usually a
plastic oval.

The notion of turning the face and indeed the
whole body into a mask is not a new one, but
today we can do so in very powerful ways. Not
only can we hide blemishes or idiosyncrasies
that might distinguish us, but by injecting our-
selves with liquid or drawing our skin tight we
can abstract our bodies from the inside out. As
scientists experiment with gene technology,
this masking might reach a point where we can

top:

RAY-BAN "AVIATOR" SUNGLASSES, 1996, BAUSCH & LOMB

These glasses were developed for fighter pilots immediately before World War II and were popularized by General Douglas MacArthur. They turn eyes into elongated ovals.

bottom:

RAY-BAN "WAYFARER" SUNGLASSES, 1996, BAUSCH & LOMB

These glasses were once the badge of American tourists, but their association with travel to exotic places has become subsumed into a vaguely nostalgic, but also futuristic, form.

choose such forms even before birth.

The lipstick, however, maintains a certain ambivalence. It is a type of sheathing that we use to repel as much as to attract, and it is both a lip preserver and a kind of blank shield to confront those whom we do not know. There is therefore a relation between lipstick and condoms, and this is true not just because of the phallic implications of both. Lipstick is something we apply to the body, and its often dark, phallic shape can have either a menacing or an enticing quality to it.

previous pages:

PETIT SHADOW (DUO): ULTRAVIOLET, 1996, SHISEIDO COSMETICS, LTD.

This simple oval of black plastic is a classic compact shape, but its ovoid perfection has been slightly altered—through the slight inflection of the compact's bottom edge and the clever housing for its brush—to recall the contours of the human palm.

right:

EAU DE PARFUM, 100 ML, 1994, COMME DES GARÇONS PARFUM

Here the bottle itself seems to be melting back into the liquid from which it was shaped, promising a sensual dissolution of the body that wears the scent.

SURF
BOARD

PLASTICITY

IN A WORLD

OF FLOWS

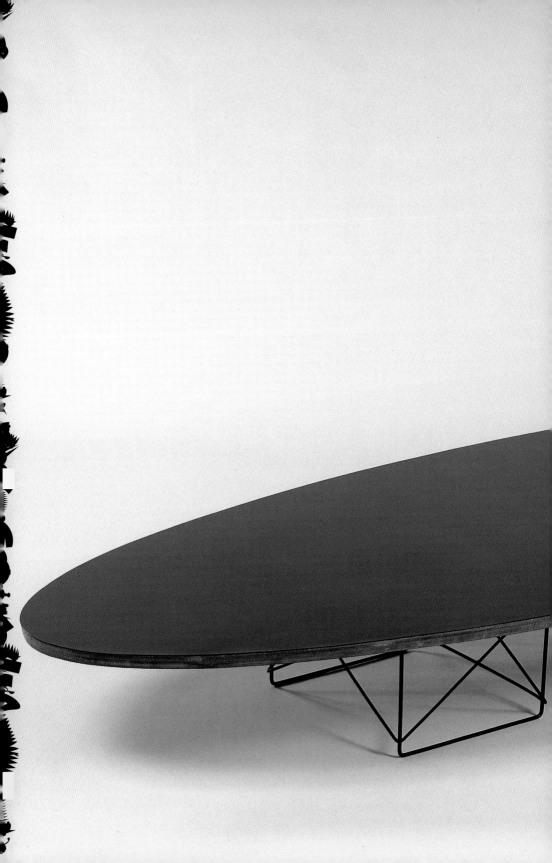

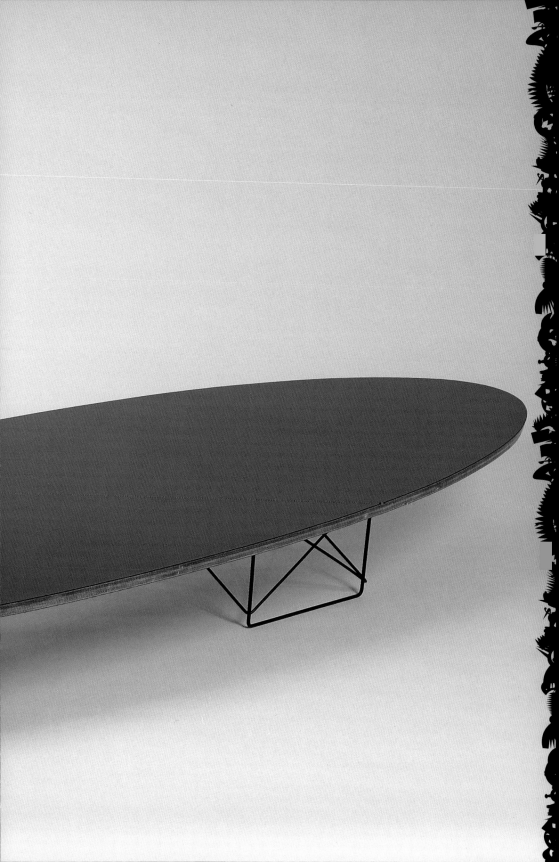

previous pages:

SURFBOARD, 1964, JACK O'NEILL

O'Neil made the transition from surfer to "shaper" with this classic long board, the first one he formed of fiberglass to ride the waves of Monterey

Bay, California. He later designed surfwear.

ELLIPTICAL TABLE, ROD BASE, CA. 1951, CHARLES AND RAY EAMES FOR HERMAN MILLER, INC.

The Eameses were inspired to design this table by the surfboards they began to see appearing in the neighborhood around their office in Venice,

California, after World War II.

right:

"THE ANIMAL" WETSUIT, 1990, PAT O'NEILL AND VENT DESIGN FOR O'NEILL

Originally developed for windsurfers, this suit provides "Smooth Skin" and "Fluid Foam" padding at the chest and elbows, as well as "Launch

Padz" (injection-molded knee pads). Its cyborglike quality has made it popular with surfers, who with this suit can transform themselves into

something other than human.

The Hawaiian word for *surfing (he'enalu)* means "to turn from solid into liquid form," and that is what the surfboard promises its riders. At the very end of the great road west, which generations of Americans hoped would lead them to a better world, along the beaches of California and Hawaii, where that paradise turned into an ephemeral moment in which youth could celebrate its independence, surfing became the final refuge. Riding the large waves of the Pacific Ocean, the surfboard offered a vision of a release from everyday life, for however short a moment.

Surfboards as we know them today are the result of the technological innovations of World War II. Both the mass influx of population and the advances in the use and acceptance of artificial materials that occurred in California during the 1940s made it possible for Preston Peterson to mold the first fiberglass board in 1946, thus creating a lightweight and affordable vehicle for escape. The sport quickly spread around the world and became the focal point of a cult that itself influenced the "turn on, tune in and drop out" movement of the 1960s. Since that time, only relatively minor advances have been made in the design of boards. They are still "shaped" of fiberglass in small-scale shops.

SURFMAN, 1996, PAUL MONTGOMERY AND HERBERT PFEIFER FOR LOGITECH, INC.

This cordless computer mouse is curved to accommodate itself to the shape of the hand but derives its name and image from the idea of surfing electronic waves.

with a stringer, or reinforcement bar, running down the middle. After a brief period when a short board was popular, the long board, though with a sharper nose, has reappeared.

Surfboards express a particular relation between the body and technology. An experienced surfer will commission a board of a certain shape depending on where he or she "rides" and work either with an artist or with company decals to customize the board. Though some "shapers" have experimented with computer-aided design, the craft remains primarily one dedicated to teasing out by hand a shape that rides the waves and supports a particular body.

It is also an example of the type of intuitive, smooth, and body-centered design that has brought designers away from the notion of generic form toward an emphasis on shapes with fluid properties: "blob" design has replaced blocks with rounded forms as the elements of a more streamlined response to the complexities of modern life. Thus we use "aqualined" or streamlined computer mice, electric shavers, and cars, without worrying about their strange shapes, because they trace our bodies.

The elongated oval of the surfboard is also the most practical form of what appears to be a modernist emblem: it resembles the elongated

top:

PANASONIC LADY'S SHAVER, 1996, AURELIE TU FOR HAUSER, INC.

Here the shape of the hand and the leg find a negative mold in the contours of this plastic object, which conveys the sense of gliding over the body like water. The recharging base strengthens these visual allusions.

bottom:

GYROPOINT PRO, 1996, GREG SMITH FOR GYRATION, INC.

Liberating the mouse from its pad, this control device allows you to point and click in three dimensions. Its radio frequency technology hides in an ovoid shape that resembles a pebble more than a tool.

circle that shows up as the faces on Picasso's women painted in the 1920s, in Brancusi's *Bird in Space*, or in the "egg" of a universal theater Walter Gropius envisioned at the same time. After World War II, this shape enjoyed a brief heyday in furniture design, with Charles and Ray Eames's "surf table" of 1951 being perhaps the most elegant example. Today, designers continue to be inspired by the notion that solids can melt into liquids, and that the body can be one such form. They create objects that fit into our hands and against every curve of our body, so that we can glide more comfortably through urban sprawl or surf the Internet without strain.

NOGUCHI TABLE, 1948, ISAMU NOGUCHI FOR HERMAN MILLER, INC.

A coffee table that seems to curve continually, this object is typical of the biomorphic forms of the 1950s but also is indebted to the Japanese tradition of gestural abstraction in which Noguchi was trained. It also is known as the "boomerang table."

BASE
BALL
BAT

POWER PLAYS

The baseball bat is the perfect hitting imple-
ment. It is round, of one piece, and balanced in
its elongated form. Unlike a paddle or racket, it
does not have complicated parts or pieces. It is
not hooked like a hockey stick or made, like a
tennis racket, of many different materials. It is
just a man-made version of a wooden log capa-
ble of sending a ball out of the ballpark—or of
bashing our brains in. We think of baseball bats
as the conveyors of memories of innocent sum-
mers, but they are also lightning rods for big
business.

The perfectly balanced Louisville Slugger was
developed by a young teenager named Bud
Hillerich in 1884 for the original slugger, Peter
Browning of the Louisville Eclipse. This bat was
not the refined form we know today: it was fat
and fairly uniform from top to bottom. Over the
years, Hillerich and his partner, the salesman
Frank Bradsby, pared the bat down, and it has
become slimmer ever since. Though the slug-
ger is what most of us think of as the best
baseball bat, the choice of a particular bat is
the result of the tastes and needs of each indi-
vidual batter. Aluminum bats, which came on
the market in the 1970s, give a greater degree
of power for less weight. They also abstract the
bat even further into a finely milled implement.

previous page:

THE LOUISVILLE SLUGGER, 1996, HILLERICH & BRADSBY

Originally designed by Bud Hillerich for Peter Browning, this wooden implement is still favored by many amateur and professional baseball players.

It draws on intuitive knowledge, honed over years of experimentation, for its balance and on the ash forests of the Southeast for its material.

right:

AIR PIRANHA BICYCLE HELMET, 1995, ROBERT EGGER FOR SPECIALIZED

This extremely lightweight helmet is made of a PETG microshell and a GESET polystyrene liner. Its ribbed structure protects the head without

suffocating it, while helping to transform the wearer into a more aerodynamic wedge.

previous pages:

NARA SPORTS SKI BOOTS, 1990, TAMOTSU YAGI

A Japanese designer living in San Francisco, Yagi designed these translucent boots for the Japanese market, where they were available for only

one season.

TACOMAH CYCLING SHOES, 1996–97, ADIDAS AMERICA

All cleats and straps, these are not so much shoes as they are connective devices that make the foot an integral part of the machinery of the bicycle.

right:

WILSON OFFICIAL NFL FOOTBALL, 1996, WILSON SPORTING GOODS

The design of the football is supposed to be a compromise between the conflicting needs for it to be aerodynamic and to be gripped by the human

hand, yet its ovoid shape makes it an alien and difficult-to-handle object.

Yet the wooden slugger, which is just as mass-produced as the metal version, remains fixed in our minds as a nostalgic version of the ultimate hitting tool. This is not only because of its long history, but also because of its elongated shape, which culminates in what appears to be an overly heavy end, so that it conveys a sense of strength through a levered energy.

As a result, the slugger has a slightly menacing air. It conveys the inherent violence of the form, so that we realize the bat can be used to crush a skull just as easily as it can hit a home run. This violence is inherent in almost all sports implements, from the protective gear we wear to play football or hockey or to climb a mountain, which makes us look like high-tech knights suited for battle, to the various hitting implements we use, such as bats and rackets, to those "sporting" tools we employ to actually kill living things. It makes us realize the strangeness in even these violent tools, and makes us wonder whether their terrible beauty is not implicit to their finely honed forms.

Sports contain and channel our aggressive behavior into a stylized ballet of bodies in intricate motion. The gear we use in performing both team and solo sports has become honed to standardized forms that create a direct rela-

EASTON BE40T BASEBALL BAT, 1995, EASTON SPORTS, INC.

While considerably stronger and lighter than its wood counterpart, the aluminum bat conveys a sense of machined perfection. The bat first appeared on the market in 1971.

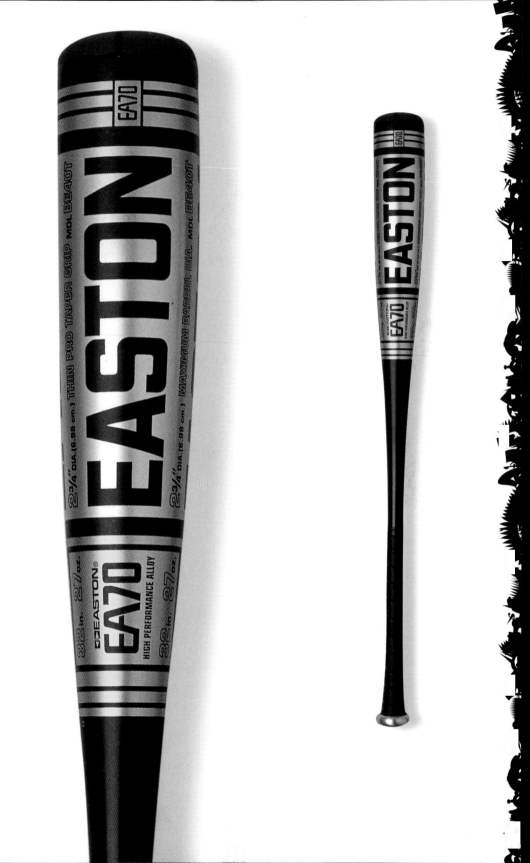

tion between our hands, gravity or wind resis-

tance, and the invisible rules of the game. A

football's oblong shape is not quite round and

not quite oval, but sums up the peculiar tradi-

tions, rules, and dynamics of that game.

Sporting goods are also fashion statements. As

much as they allow us to hit harder or run

faster, these outfits are also uniforms that

identify our pursuits. Instead of paring our bod-

ies down, padded football jerseys, running or

climbing shoes, and cups become artificial mus-

cles or armor that bulge to present a vision of

ourselves as cyborgs ready to play in a world

where technology continually defines new chal-

lenges for us. They are emblematic gear for a

world in which we often engage in ritualized,

electronic warfare.

top:

KAISER CUP SOCCER SHOES, 1996, ADIDAS AMERICA

In this updating of the classic soccer shoes worn around the world, Adidas emphasized the shape of the shoe instead of the binding, while blending

the signature "three stripes" into the overall design.

bottom:

TAILWIND NIKE, 1979, NIKE, INC.

This classic running shoe helped popularize the Nike Swoosh, itself an emblem of the body in motion. Sole, toe guard, and body are all curved into

a unified composition.

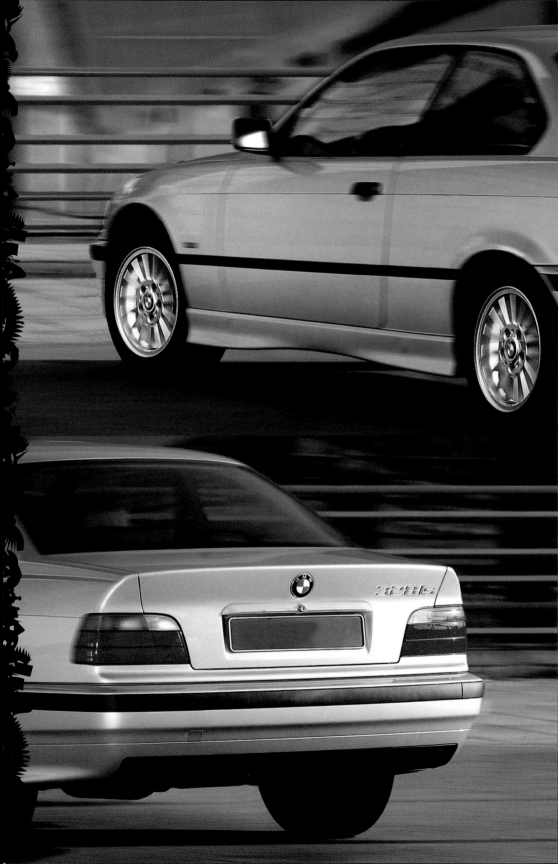

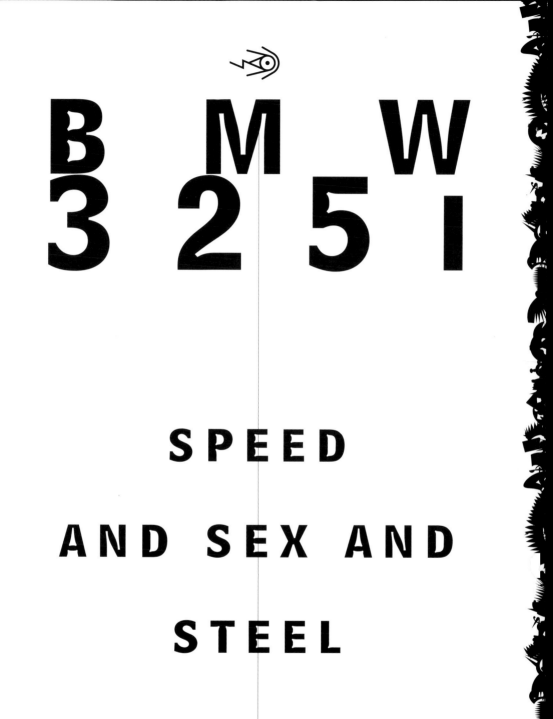

BMW
325i

SPEED

AND SEX AND

STEEL

For a car that many see as the ultimate yuppie status symbol, the BMW 325i has a somewhat ominous history: the first version was built between 1937 and 1940 for the German military as a jeeplike, armor-plated vehicle. The current car, however, has little in common with its predecessor. The 325i is the very embodiment of sleek, smooth, and perfectly balanced consumer motion. It is the luxury car that is supposed to be affordable. It is designed to make us feel safe, fast, modern, and perhaps even sexy. It sums up the ways in which cars have become not only the prime movers of our automotive society but also the most expensive disposable objects many of us choose to define ourselves.

There have been three versions of the current model, the first appearing in 1972. Though enthusiasts may argue about the merits of each, what stands out is the manner in which each generation of this car has become more abstract, cleaner in its lines, and better balanced. This has also meant that the 325i has begun to resemble many of its competitors, both because it has been imitated so often and because the sophistication of computer modeling, market research, and production engineering tends to reduce cars of all kinds to only a

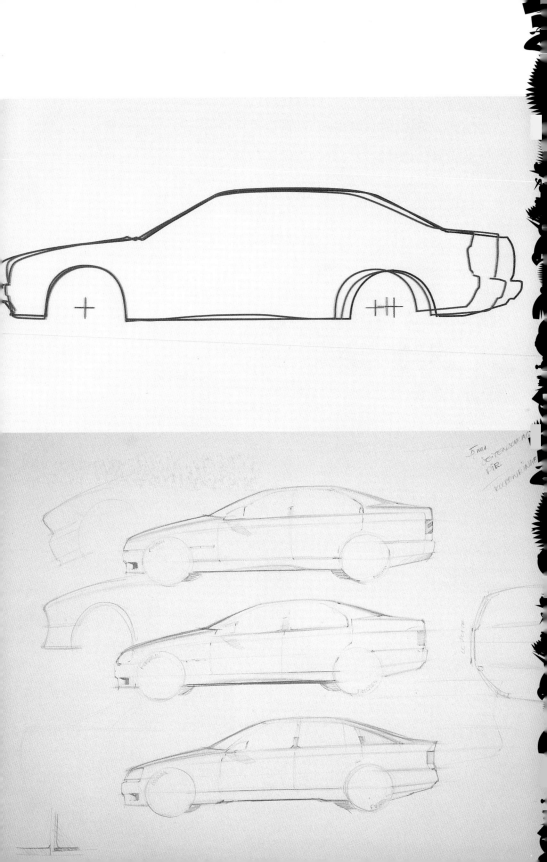

previous pages:

APRILIA MOTO´ 6.5, 1995, PHILIPPE STARCK FOR APRILIA S.P.A.

Design wizard Starck is also a motorcycle rider. Here he marries the technological expression of classic American "hogs" and British motorcycles

with the fluidity of form and menacing aerodynamics of the sort pioneered by Japanese designers in the 1980s.

DUCATI 916 STRADA, 1996, DUCATI MOTOR S.P.A.

This motorcycle reduces the expressive forms of the "road warrior" bikes to a compacted shape. The model is sold only in red.

right:

CHRYSLER NEON ADVERTISEMENT, 1994, BOZELL WORLDWIDE

When Chrysler released the Neon, the company wanted to give the economy car "personality." This advertising campaign succeeded in focusing all

attention on the anthropomorphic implications of the design.

Hi.

few variations on a basic design.

The BMW 325i manages to emphasize the refinement of the car from a chariot with frills or a box on wheels into an aerodynamic, impact-resistant, computer-molded wedge with a particularly well composed form. The sweep of the front denotes speed, the layering of the lines along the sides lets us sense a density of engineering, and a certain fullness to the car's compact form gives us the idea that this is not just a racing machine but a smaller version of a sedan. Every line is in delicate balance with every other line to create a car that changes its stance depending on how we look at it, what advertising we read, or in what context we see the car.

The parameters within which automotive designers work are extremely narrow, both because of engineering and cost concerns (they have to use a minimum of material to create maximum strength and efficiency) and because these cars have to appeal to hundreds of thousands of individuals. It is rare that a strong concept, such as the "egg" or "landau" image of the Infiniti J30, the minivan, or the retro sports car of the Miata (designed by Tom Matano, who was also part of the team that developed the current 325i), sets a new paradigm. Even when it does, the original model or

top:

NISSAN INFINITI J30 LATE PROTOTYPE, 1989, NISSAN DESIGN INTERNATIONAL, INC.

This full-scale model was used to study the overall impression the car would make. It is among the most fluid and balanced designs currently on the market.

bottom:

NISSAN INFINITI J30 DESIGN SKETCH, 1989, CHRIS LEE, NISSAN DESIGN INTERNATIONAL, INC.

Lee called this the "egg in the landau" scheme. It tried to express the heritage of a car meant for the carriage trade that also had to convey a sense of abstract elegance.

image becomes translated into an abstract and almost generic form that has just enough novelty to appeal to the market in a new manner.

Cars, whose lines come together these days into something between a wedge and an oval, are what move between us and a world of continual motion. They go with the traffic and the changing landscapes of our daily lives, turning smoothly (we hope) within a confusion of possible destinations and competing forces. They provide us with an enveloping cocoon. They also isolate us from the rest of the world and demand that much of our urban spaces arrange themselves according to their rules. The power they possess gives the best-designed automobiles a certain regal grace that can also become an image of an alien spaceship transforming us into machines devouring the road—a sense heightened by the more aggressive shapes of motorcycles. The BMW 325i is, in all its fluid, dynamic balance that sweeps through the streets with a certain haughty stance, indeed the ultimate driving machine.

MIATA, 1990, TOM MATANO FOR MAZDA MOTORS

Matano took the essential elements of such classic sports cars as the Triumph and pulled them taut over a modern frame, giving the whole as much a futuristic as a nostalgic aura.

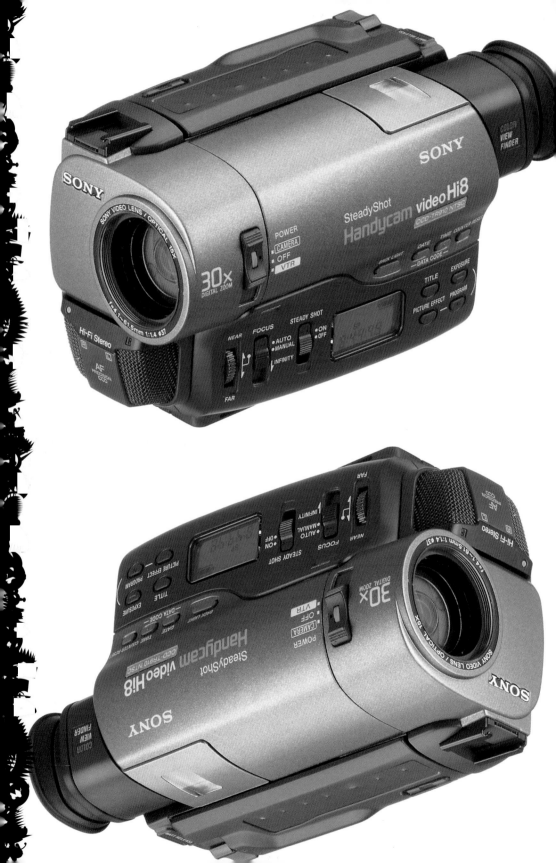

MINI CAM

YOU ARE BIG BROTHER

Though small cameras have been available for many years, the more recent miniaturization of technology and the simplification of controls, combined with the availability of play-back devices, have made the camera into a potential continuation of the roving eye that moves through our changing landscape and frames it to allow us to comprehend our surroundings.

The design of the minicam draws on two models: the small still camera, which ultimately has its roots in Kodak's famous Brownie of 1889; and the film camera used to create motion pictures. The latter model still dominates the design of the minicam: it is a compacted and more streamlined version of the protruding lens broadened into an object that contains the mechanics of recording while allowing the hand, through a manipulation of the controls on the surface, to adjust what we see through the lens. Recently, however, the framing device of the still camera has inflected this model toward squarer forms that resemble the frame around a picture, here turbo-boosted to control moving images.

Minicams are objects that mediate between us and the world. They take in a wide arena of views and condense them to fit inside their bodies. Another set of lenses then makes the images available to our eyes, and their shapes

previous page:

SONY STEADY SHOT HANDYCAM VIDEO HI-8 CCD-TR910, 1996, SONY ELECTRONICS, INC.

The latest version of the Sony Handycam packs more variables than ever into a smaller body. It celebrates its mechanical nature with a metallic plastic skin.

right:

AETHERWORKS WFM TELEPHONE, 1996, MARK JOHNSON OF TONIC INDUSTRIAL DESIGN FOR AETHERWORKS CORPORATION

Johnson designed this cellular telephone to emphasize the enclosed, dense nature of the object; its rigid, futuristic symmetry; and its ability to fit into the hand.

previous pages:

ITT NIGHT MARINER 150, 1996, ITT NIGHTVISION

First developed for the Soviet military, this infrared device combines the shape of a grip with a prominent lens. The yellow color makes it highly visible at night, thus removing it from the realm of surveillance and placing it, like many of these objects, in a world of consumer culture.

MOTOROLA STARTAC, 1996, MOTOROLA

Taking its clunky but highly efficient "flipphone" one step further, Motorola here adopts the ergonomic fluidity so common in other handheld devices. It expresses both ease of use and a sense of compact power.

right top:

SB2800 SERIES HEMISPHERE DOME, 1996, PELCO

This ubiquitous device hides a camera and all the equipment that allows the security system running it to survey a large area in a mechanical version of the "eye of God" that adorns our currency.

right bottom:

ZERO EMI MAGNUM SURVEILLANCE CAMERA, 1996, RKS DESIGN, INC.

The latest surveillance camera is no longer an ungainly pivoting eye but a tube that hides its function as a particularly potent piece of "street furniture."

are themselves abstractions of our organs of sight. The body of the camera, meanwhile, fits into our hand. It is a negative mold of our palm and fingers. This molding continues into the choice of materials. Where it is needed, a tex-tured plastic replaces the smoother variety to give our fingers a better grip.

As such, the minicam is a prosthetic device. It extends our body into the world around us and reduces that world into a form we can handle. It replaces such basic functions as seeing with a mechanical stand-in that intensifies our ability to record what we see. Because of the complex quality of this device, it does so in a particularly compacted manner, and this gives the object much of its dense beauty: each piece and curve has to do much to fulfill its prosthetic function.

The minicam also has a more frightening impli-cation. It is not only one of the most powerful prosthetic devices we can own, but it is also the smallest part of a system of surveillance that surrounds us everywhere. Nothing we do is invisible to security cameras that take up their positions on the ceiling of our rooms or on satel-lites circling the globe. The cameras near us often hide behind dark glass abstractions of that globe or act as disembodied Cyclops's eyes.

top:

OLYMPUS "O" PRODUCT, 1989, NAOKI SAKAI FOR OLYMPUS AMERICA, INC.

Designed to commemorate Olympus' seventy-fifth anniversary of camera manufacturing, this camera consciously recalls those used by newspaper photographers before World War II, here condensed into a consumer snapshot taker.

bottom:

CANON PHOTURA, 1995, CANON U.S.A., INC.

The Photura breaks out of the Kodak Brownie box to turn the still-photography camera into a simplified version of the minicam. The camera reduces to almost nothing the amount of equipment that comes between hand and lens.

Yet even on a less sinister level, these pros-
thetic devices have an ambivalent meaning in
our lives. They are part of a family of objects
that keep us "plugged in" or "wired," connect-
ed to large structures of information and con-
trol on which we are increasingly dependent for
both security and information. They smooth
over the hurdles that separate us, allowing us
to be in touch with endless streams of data
wherever we are. Computers and telephones
are the anchors in the sea of constantly chang-
ing information we need to harness to survive
in the world, but as such they also keep us
chained. The forms of cellular telephones, lap-
top computers, and other communications
retrieval and processing devices adjust them-
selves to our bodies, and they ingeniously com-
pact the world of information composed of bits
and bytes into densely packed, usually gray
plastic matter that bulges with an immense, but
undefinable, power.

previous pages:

HAPTIC SOFTWARE CONTROLLER, 1995, MICHAEL McCOY

McCoy proposed that the homeowner could scan an image of his or her own house into a silicon "blob" that had been impregnated with enough electronics to allow the owner to control all the appliances in the home in a shape molded to his or her hand.

right:

APPLE POWERBOOK 540c, 1995, ROBERT BRUNNER, APPLE COMPUTER, INC.

Continuing Apple's tradition of making computers beautiful, this simple plastic slab has edges that become an echoing arsenal of bulletlike excla-mations of each curved and pointed edge. It is a refinement of a model that had been on the market for five years.

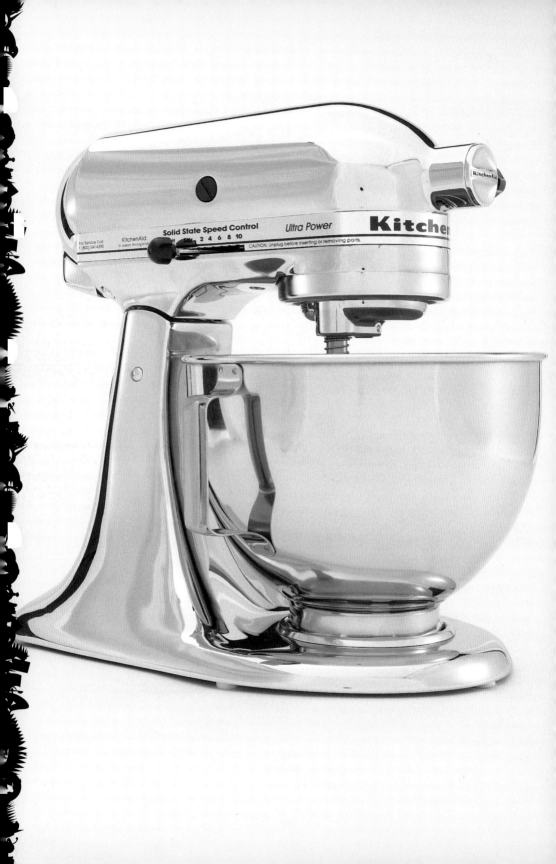

KITCHEN
A I D
MIXER

GADGETS

GALORE

The KitchenAid mixer has been around since 1920 and has not really changed much since that time. It was designed to bring the professionalism of cooking into the home and quickly became a symbol of the place where luxury and hard work met in the life of the middle-class woman. More recently, it has become a status symbol that fits in a kitchen of smooth-surfaced appliances. Its form is almost monumental, conveying a sense of weight and importance through the elongation of its bull-nosed top and the crouched power of the sweep that cradles the mixing bowl. The mixer is also a no-nonsense object filled with pretensions. In it, a piece of technology meant to produce food more efficiently has become a symbol of cooking well by having the best tools available.

Herbert Hobart, an engineer, invented the mixer in 1918 and started producing it the following year. He reduced the large mixers professional bakers used into an implement for the home. Other than cheaper variations, the introduction of different colors, and slight modifications of controls, the basic mixer has not changed since then. It still reminds us of the optimism of the Roaring Twenties, when we believed that we could streamline our society and everything in it to move more quickly to a

previous page:

ULTRA POWER STAND MIXER, 1996, KITCHENAID

A metallic version of a design by Herbert Hobart that has existed in the same basic shape for over half a century. The gleaming metallic skin emphasizes the "serious" quality of the object while further blurring its shapes.

right:

AEROMASTER, 1988, HARTWIG KAHLCKE FOR BRAUN, INC.

A variation on a design first introduced in the 1970s, this coffeemaker subsumes the various receptacles of the machine into a unified cylinder.

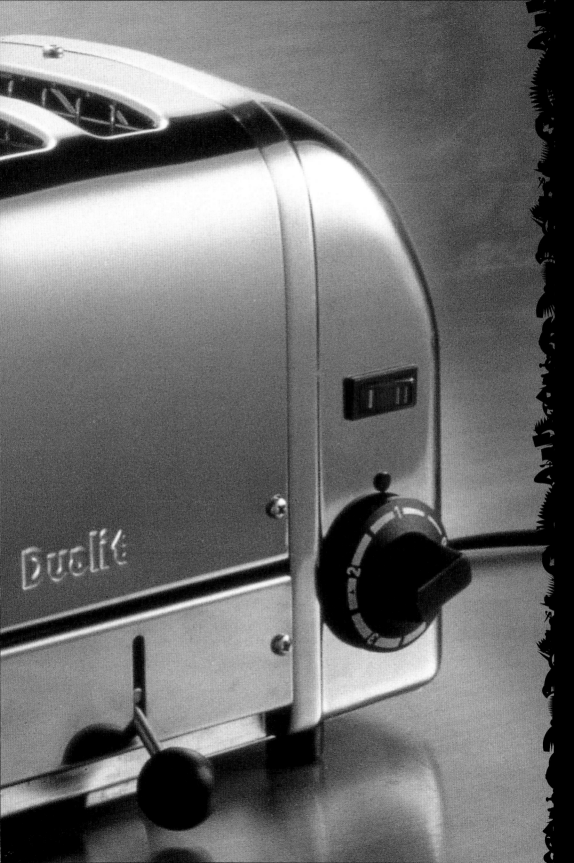

more efficient and bountiful future. Unlike other examples of retro styling that try to recover this utopian vision, however, the KitchenAid mixer does not look back but merely continues to introduce its vision into kitchens in the same way it has for over seventy years.

The kitchen has been the place where much technology has entered our lives. It has done so through a "feminization" of work and a professionalization of the role of women. The mixer stands at the intersection of the roles we have defined for women and of the perception that women want forms that are both sensible and sensual. The modern kitchen is a small version of the factory, laid out for efficient production. The tools in that room are as efficient as those created for manufacturing, but here they have been adapted to the hand and comfort of an individual. We accept the streamlining technology enforces on such tools in our home, but we also want these forms to be softer than we expect tools to be and scaled to our bodies.

These days, tools have become gadgets. They are still smooth and artificial, but, as is the case in the objects designed by Philippe Starck, they often take on vaguely animal-like traits, as if their mechanical qualities had given rise to hybrid shapes that seem somehow familiar and

previous pages:

DUALIT TOASTER, 1996, DUALIT

This monolithic object pumps up the basic action of making toast to make this particular quotidian task seem grand. The curves and grooves perform no function beyond this aestheticization.

right:

PITO, 1988/92, FRANK GEHRY FOR ALESSI

One in a series of teakettles Alessi commissioned from famous architects, Gehry's version offers his personal fetish object, the fish, in an abstracted form as both handle and spout. The forward stance of the object seems to push the steam out.

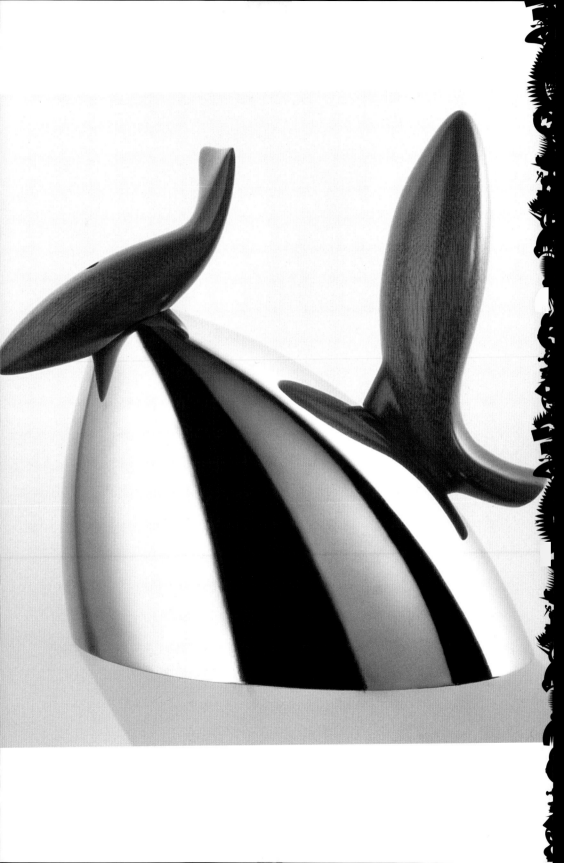

JUICY SALIF, 1990-91, PHILIPPE STARCK

In an era when squeezing juice is a ritual rather than a necessity, this juicer evokes space travel, the rococo modernism of 1950s tropical resorts, and the classic juicer, here liberated from its ponderous base.

INTERPLAK POWER TOOTHBRUSH, 1996, BAUSCH & LOMB ORAL CARE DIVISION

DESIGN TEAM FOR CONAIR

Bringing the technology of the dentist's office into the domestic bathroom, this rotating polypropylene brush offers an emblem of hygiene as a toothbrush bulked up to (barely) contain mechanical devices.

ORIGINAL JELLYFISH, 1983-84, SWATCH

The first of the Swatches to be introduced, the Jellyfish provided precision technology in a mass-produced, accessible form while revealing its works in a transparent casing.

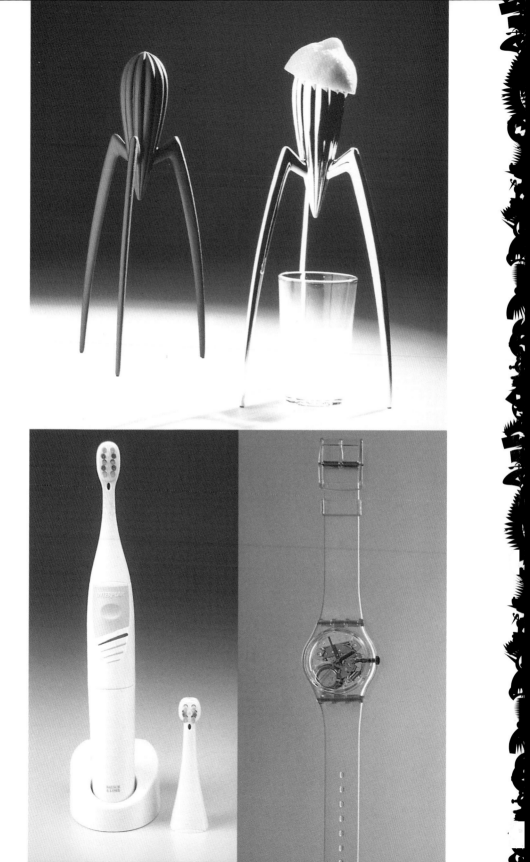

at the same time as alien as the circuitry and mechanical parts they contain. Gadgets are both pets (like the Dyson vacuum cleaner) and status symbols (like the Braun or Krups coffeemakers), but ultimately they are implements: they are tools that make a world that otherwise presents itself to us as something beyond our control into solid shapes we can desire, use, wear down, and throw out, only to look for future targets for our object lust.

top:

BECKER E.C. PHONE, 1990, ERIC CHAN FOR ECCO DESIGN, INC.

This "soft phone" makes the act of picking up an electronic device into a sensual experience. It draws on the white Princess Phone for its shape, but its black rubber casing gives the object a sense of drama.

bottom:

DYSON DC02, 1996, JAMES DYSON FOR DYSON APPLIANCES, LTD.

Dyson is an entrepreneurial designer and inventor who began his appliance company with this beastlike vacuum cleaner. In addition to looking like a dust-eating monster, it works much better than standard vacuum cleaners because it uses a clear bin rather than a bag to collect the dust.

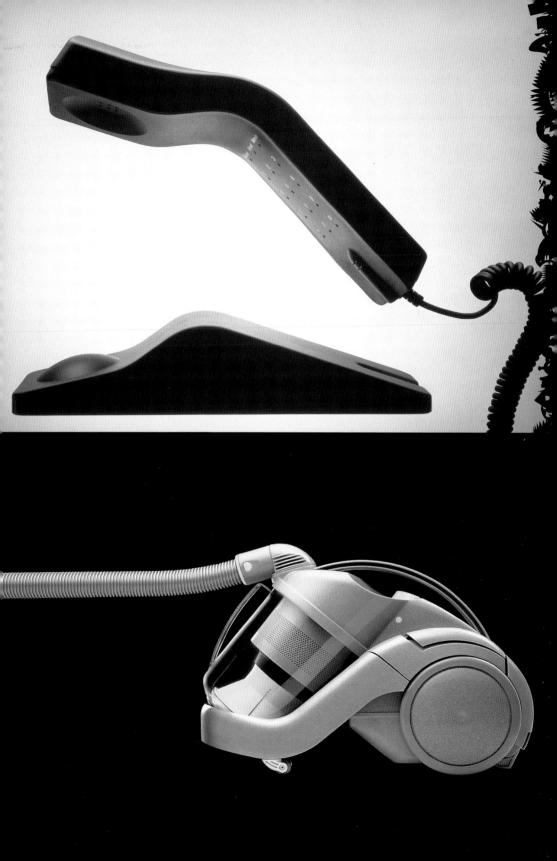

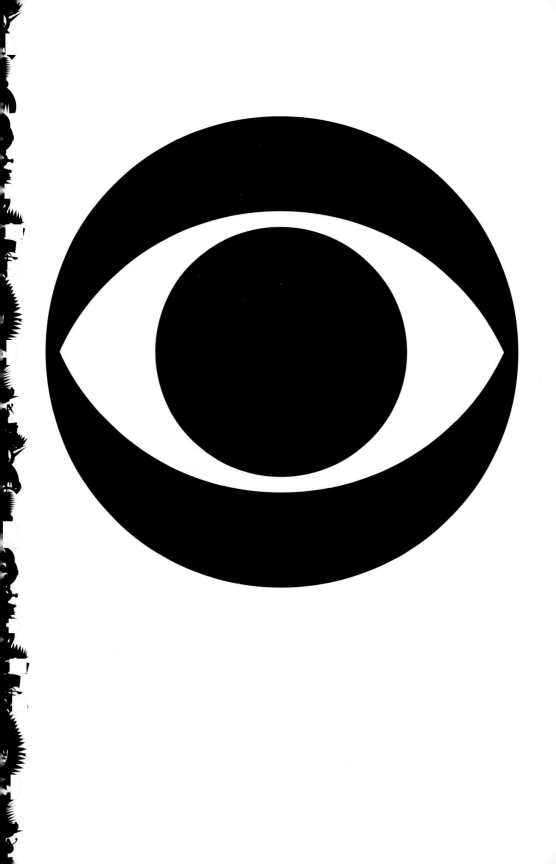

C B S
L O G O

CO-OPTING

THE

CORPORATE

previous pages:

CBS LOGO, 1996, CBS INC.

The now ubiquitous logo was designed in 1951 by Bill Golden, based on the "eye of God" that Amish farmers painted on their barns to ward off evil. Though the eye has become animated and colored, its basic shape has not changed in forty-five years.

MERCEDES-BENZ HOOD ORNAMENT, 1952, DAIMLER-BENZ AKTIENGESELLSCHAFT

In contrast to the woman in flight who serves as the Rolls Royce hood ornament, the Mercedes-Benz star reduces the car's emblem to an almost archetypal shape. When the company adopted it in 1909 there were already thirty-one similar trademarks in use.

PEACE SYMBOL PENDANT, 1996, ANONYMOUS ARTIST

This symbol is an abstraction of the semaphore sign for nuclear disarmament popularized in the 1950s. The V shape is also an adaptation of the Victory gesture popularized by Winston Churchill. In the mid-1960s it replaced the dove as the universal symbol of peace.

right top:

NIKE SWOOSH, 1971, CAROLYN DAVIDSON

The Swoosh was created by a Portland State University student. It is based on the winged sandals traditionally worn by Mercury, the Roman god of speed (and commerce).

right bottom:

GREEN COCA-COLA BOTTLES, 1962, ANDY WARHOL

Warhol made his career by adopting mass-produced objects and images, whether they were shoes or Marilyn Monroe, as artworks. This painting is part of a series that includes both serial and singular portrayals of the familiar green bottle, here turned into a convenient vessel for meaning.

Corporate logos identify abstract structures. We call them corporations, and these bodies are complex mechanisms for processing information, organizing resources, manufacturing products, distributing things, and making us buy whatever they have set themselves up to sell. In one single image, these logos or graphic devices have to make all of this present. They have to be the concrete aspect of a system that is often so complex and unknowable that we can never hope to truly comprehend it. Their very power in doing this often makes them so effective that they awaken a host of other associations. They begin to stand for wider categories of consumer experiences (like Coca-Cola), for evil empires of capitalism, for liberatory possibilities (like the Nike Swoosh), or for a whole cultural mythology that pervades every aspect of our lives (like the famous mouse ears that stand in for the fairytale land over which the Walt Disney Corporation rules). The CBS Eye logo does its task with amazing economy. It conflates into its few forms the notion of watching and being watched, bringing a system of vision into a by-now familiar form that is completely anthropomorphic and yet general enough to identify an institution of broadcasting. It was designed by CBS Creative

left:

RIDICULOUSLY PRACTICAL, 1985, DAN FRIEDMAN

Friedman created this T-shirt to advertise a lecture series at New York University. The shirt was produced by Williwear, whose graphic design program he directed. Here Friedman, who designed the Citibank logo, seems to be appropriating the CBS Eye logo.

right:

DISNEY PENCIL, 1996, THE WALT DISNEY COMPANY

It is amazing the uses to which mouse ears can be put. What started as a slightly mischievous cartoon character has become the indicator for a conglomorate, recognizable even as a negative outline.

Director Bill Golden in 1951, supposedly after he saw a similar sign on barns in Pennsylvania, where it was meant to ward off the evil eye. It certainly resembles the "eye of God" that still adorns our currency, but here it has lost its specific physical characteristics. It is the eye of the camera, which sees all and brings that information to millions of viewers. It is also the eye of the viewer who, like God, now sees all. It is, finally, the eye of the corporation, which sees both the world and the viewer. All of this power is contained in a set of graphic elements that are in themselves not expressive. Not quite gestures and not quite Platonic ideals, logos such as this evoke both a part of the body and a noncorporeal structure at the same time.

Many of the most successful logos today are vaguely circular. With this shape, they draw on the tradition of the mandala, a graphic device that represents the world and its forces in miniature form. By reading the mandala, we can find our place in the world. These mandalas also sum up the graphic information they seek to convey. Rarely are these forms pure circles, however: the other information they seek to convey distorts or deforms them. This is true of such corporate identifiers as those used by Citibank, Time Warner, and Mercedes-Benz.

TIME WARNER CABLE LOGO, 1990, STEFF GEISBUHLER FOR CHERMAYEFF & GEISMAR, INC.

When Time and Warner merged, they needed a logo that would embody their various entertainment and information businesses. The combination of the eye and the ear into a mandala-like symbol, however, failed to achieve popular acceptance.

MACINTOSH ICONS, 1996, APPLE COMPUTER, INC.

These computer icons humanize the computer box, making it into a figure with a face and a container of familiar office implements.

APPLE LOGO, 1977, ROB JANOFF OF REGIS MCKENNA FOR APPLE COMPUTER, INC.

The apple here is the fruit of knowledge of which mankind has tasted. Instead of sin and perdition, it brings fun and games. The rainbow colors recall the post-hippie culture of technological appropriation in which the company took root.

We can appropriate these logos, wear them, change them, and make them our own; thus, a Mercedes logo can become a peace sign, the CBS Eye can be a T-shirt emblem, and the Citibank logo can become a decorated fetish. In this way, we gain access to this vague world of abstract corporate structures by using and deforming the concrete, if enigmatic, images they evoke.

CITIBANK LOGO SKETCHES EXHIBITED AT ANSPACH GROSSMAN PORTUGAL, INC., 1975, DAN FRIEDMAN FOR CITIBANK

When Citibank changed its name from City National Bank, it needed a symbol that would both contain a memory of the company's origins and encompass a sense of its new global reach in a suitably neutral sign.

UNTITLED, 1980, DAN FRIEDMAN

Friedman turned the Citibank logo he had designed in 1975 into the centerpiece for this wall fetish. It was part of the three-dimensional artwork that was his apartment in Manhattan.

⊗

@

MARKING

THE

ELECTRO

SPHERE

previous pages:

@ SYMBOL

Officially known as the "commercial a," the @ was adopted in 1972 as the computer-address designator by Ray Tomlinson when he was helping to design Arpanet, the predecessor of the Internet.

LEVI'S 501 ADVERTISING POSTER, 1995, TOM BONAURO

Part of a purposefully enigmatic advertising campaign, these concentric circles zero in on the equally nondescriptive model name for the jeans that Levi Strauss would like to present as the archetype of American clothing.

right top and bottom:

A TOMATO PROJECT, 1996, TOMATO

The British graphic design collective Tomato produced this CD-ROM as an advertisement for their wares, which include print, advertising, and television design. All the information is contained in various layers of dots that float across the screen, pulse with snippets of imagery, and provide access to full-screen examples of the firm's work. Clicking on the dots starts movies running, changes voice-over music, or provides samples of page layouts. The end result of navigating through this field of information is not clarity, but a seductive presence of fragments torn from the streets, television, or computer programs and gathered into compositions with the very short shelf-life of mass-media imagery.

In a world of urban sprawl, we are increasingly nomads who alight in one spot only momentarily. Once there, we couple ourselves to a place, and to a sense of belonging, through signs, ciphers, or figures. Our telephone number, our street address, our various account numbers, our social-security designation, and the street signs that tell us where we are—all of these contain, in both a direct and a symbolic manner, the information that tells us we are at home. The @ symbol is the most recent of such designations, and perhaps the most mobile. Through this sign, we couple ourselves, not to a location, but to a system of information. We can take our address with us no matter where we are, but it defines us as a member of either an institution (a company or government agency) or a service. With the @ symbol we are both someplace very specific, where any computer in the world can find us, and nowhere at all.

The "commercial a" symbol first became the designation of an address in the precursor of the Internet, the government-sponsored Arpanet, through the decision of Ray Tomlinson, an engineer who invented a way for different computers to exchange files with each other. The symbol has a long history in both

top:

LEVI'S 501 ADVERTISING POSTER, 1995, TOM BONAURO

These images were displayed in stores to evoke a mysterious aura around a pair of jeans. The images come from television, news, and other media.

bottom:

ADVERTISING POSTER FOR EDWARD FELLA'S FELLAPARTS, 1994, RUDY VANDERLANS AND GAIL SWANLUND

This poster was published by "Emigre," a company that spearheads typographic innovation. The Fellaparts transform the alphabet into a Gothic fantasy of half-sinister, half-playful emblems.

501

fellaparts
1 7 0 ILLUSTRATIONS IN FONT FORMAT
DESIGNED BY EDWARD FELLA
AVAILABLE EXCLUSIVELY FROM
EMIGRE FONTS

WIPO Proposal Would Turn Artists into Pirates

Voyager Absorbs Holtzbrinck Electronic Publishing

Jobs Reportedly Headed Back to Apple

Court Cracks Open Crypto Policy

WIPO Proposal Would Turn Artists into Pirates

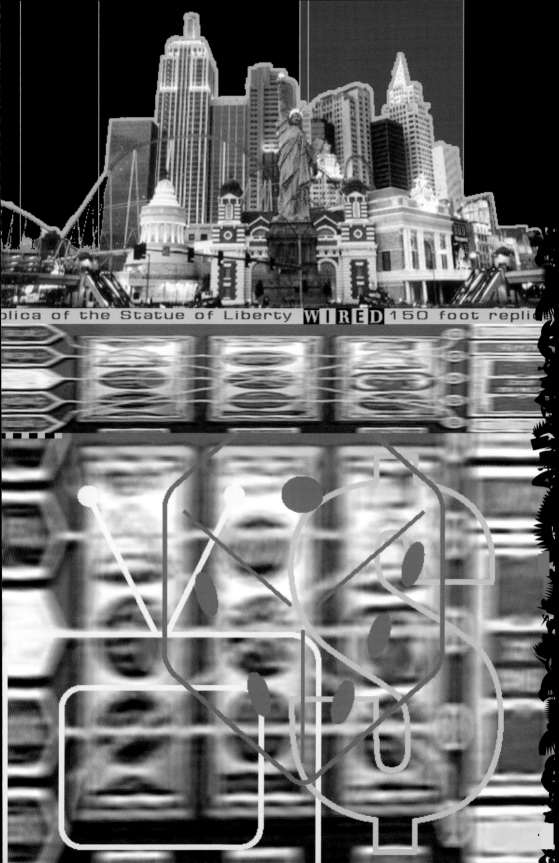

plica of the Statue of Liberty **WIRED** 150 foot replic

science and commerce as a designator of place. It derives from the Latin *ad*, meaning "near" or "at." As the Internet grew, so did the use of this particular symbol, to the point where it is now used as the title of a magazine and an Internet-access service provider. What was a few decades ago only a commercial sign and obscure scientific designator has now become one of the most ubiquitous signs of our daily lives.

The @ is a condenser of the word *at* that wraps its very terseness around itself. It takes the word and makes it into a rounded image of itself, floating slightly above the line of the rest of the letters. This kind of deformation of normal letters is akin to the transmutations that words have undergone since the introduction of computers. These devices, which ultimately reduce everything to on/off, or 0 and 1 in computer code, tend to reveal the nature of our language as a code that we must translate when reading or hearing words we otherwise take for granted.

Graphic designers have sought to express the malleability of language by creating layouts and typefaces that do not so much increase our ability to read a text or get information as they make the coded nature of language visible. Certainly

previous pages:

ERIK ADIGARD, LIVEWIRED DESKTOP SCREENS, 1997

These screens are part of a desktop environment using "push" media technology. In collaboration with producer Gary Wolf and technical designer Taylor, Adigard created these screens, which change in response to contemporary events and deliver news to computer users.

right:

ADVERTISING POSTER FOR JOHN HERSEY'S THINGBAT AND BLOCKHEAD FONTS, 1995, RUDY VANDERLANS

The thingbats and blockheads are based on type figures traditionally used to highlight or annotate regular type. Here the computer allows us to print out a text with these characters rather than with letters.

John Hersey's Thingbat and Blockhead Fonts. Available exclusively from Emigre Fonts.

the ability of computers to instantly change the design of a page has made it possible for information to be organized in almost any fashion. We can also create any kind of typeface, so that what appears in one form on our keyboards or screens may appear as something completely different once we print out the page.

The density and malleability of graphic design that results from this freedom and the desire of designers to convey as much information as possible have become themes for some of the best designers in the field. They have chosen to see their work as something that purposefully obscures the page, forcing us to redefine our relationship to the information we want, making us aware of the materiality of what is bringing us the message (the medium) and ultimately questioning our ability to make sense of what we are seeing.

top:

SPREAD FROM EMIGRE #8: ALIENATION, 1987, RUDY VANDERLANS AND ZUZANA LICKO

For an article that questions the very notion of the accessibility of information, this layout proposes a blurred and menacing field of ink.

bottom:

"ACROSS ILLEGIBILITY," EMIGRE #18: TYPE SITE, 1991, PIERRE DI SCIULLO

In this image, di Sciullo set a fragment from Shakespeare's "Hamlet" in an evocative, but not very readable, type he designed.

and
continue
to watch
the movie:

AND DATA TAPES

"I do like to shop. I'm probably well known for my shopp...

"... news. Right **NOW** with America...

"I don't ... if you are interested in ... REC

and the ... financing or up to a thousand dol...

... Combine the cash back offer ...

up to **two thousand one hundred eleven dollars** on these best selling pickups.
HAMBUR... SOMETHING HOT, JUICY, AND SO UTTERLY SIMPLE, THAT YOU CAN
EAT IT WITH YOUR HANDS. I MEAN I KNOW PEOPLE WHO DON'T EAT BURGERS.
BUT I'M NOT SURE I TRUST THEM.
Great value programs also offered on most Big board pickups.
Take advantage of these savings **now!**"

King O, My offence is rank, it smells to heaven,/ hath the primal eldest curse upon't,- A brother's Murder! - Pray can I not, Though inclination be as sharp as will: My stronger guilt defeats My strong intent; And, like a Man to double business bound, I stand in pause where I shall first begin, And both neglect. What if this cursed hand Were thicker than itself with brother's blood,- Is there not rain enough in the sweet heavens To wash it white as snow? Whereto serves Mercy but to confront the visage of offence? And what's in prayer but this twofold force,- To be forestalled ere we come to fall, Or pardon'd being down? Then I'll look up; My fault is past. But, O, what form of prayer Can serve My turn? Forgive Me My foul Murder!- That cannot be; since I am still possess'd of those effects for which I did the Murder,- My crown, Mine own ambition, and My queen. May one be pardon'd and retain the offence? In the corrupted currents of this world Offence's gilded hand May shove by justice; And oft 'tis seen the wicked prize itself buys out the law.

King O, my offence is rank, it smells to heaven,/ hath the primal eldest curse upon't, A brother's murder - Pray can I not, Though inclination be as sharp as will: My stronger guilt defeats my strong intent; And, like a man to double business bound, I stand in pause where I shall first begin, And both neglect. What if this cursed hand Were thicker than itself with brother's blood, Is there not rain enough in the sweet heavens To wash it white as snow? Whereto serves mercy but to confront the visage of offence? And what's in prayer but this twofold force, To be forestalled ere we come to fall, Or pardon'd being down? Then I'll look up; My fault is past. But, O, what form of prayer Can serve my turn? Forgive me my foul murder! That cannot be; since I am still possess'd of those effects for which I did the murder, My crown, mine own ambition, and my queen. May one be pardon'd and retain the offence? In the corrupted currents of this world Offence's gilded hand may shove by justice, And oft 'tis seen the wicked prize itself buys out the law.

King O, my offence is rank, it smells to heaven,/ hath the primal eldest curse upon't, A brother's murder - Pray can I not, Though inclination be as sharp as will: My stronger guilt defeats my strong intent, And, like a man to double business bound, I stand in pause where I shall first begin, And both neglect. What if this cursed hand Were thicker than itself with brother's blood, Is there not rain enough in the sweet heavens To wash it white as snow? Whereto serves mercy but to confront the visage of offence? And what's in prayer but this twofold Force, To be forestalled ere we come to fall, Or pardon'd being down? Then I'll look up; My fault

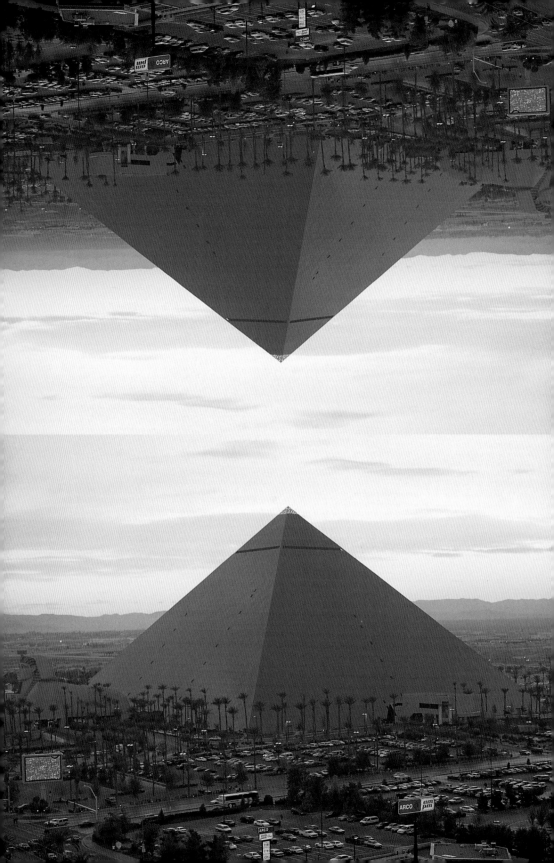

LUXOR HOTEL

SLOW

BUILDINGS

FOR FAST

SPACE

The Luxor Hotel is a perfect geometric solid. It just happens to be thirty stories tall, contain over three thousand hotel rooms, be clad in black reflective glass, and sit on the Las Vegas Strip. It is an emblem of perfection. It is the pyramid on the dollar bill made concrete, yet it is also the most abstract piece of architecture in the country. Modernist architects once promised us cities of glass in which we would live in a continual state of revelation: all would be made clear and available to us. Here, glass hides all, inviting our desires and threatening us with the danger lurking at the heart of the cities we have built for ourselves.

The Luxor, which was designed by Veldon Simpson in 1992, is a response to some very direct needs. These days, buildings such as casinos or shopping malls, which need to attract visitors, must have a "theme": they must compete with television to tell us stories. Casinos have to sell us escape into another world, that of riches and danger. Las Vegas, like the cities of ancient Egypt, stands in a desert, and since in Egypt the pyramids stood for great wealth and power, the form might seem appropriate. In Las Vegas the Strip is made to stand in for the Nile. Yet pyramids are also places of death, and the black form of this

previous page:

LUXOR HOTEL (DETAIL), 1996, HENRY WESSEL

This photograph of the Luxor Hotel, designed in 1992 by Veldon Simpson, highlights the scaleless nature of this thirty-story-tall black-glass-clad hotel.

right:

PRESENTATION MODEL FOR "SPACE IN PROGRESS" HOUSE PROJECT, 1996, MICHELE SAEE

Saee here reduces the idea of habitation to a layered ball of structure balanced on the edge of a cliff. Most of the functions of this single-family home are housed in one loftlike space.

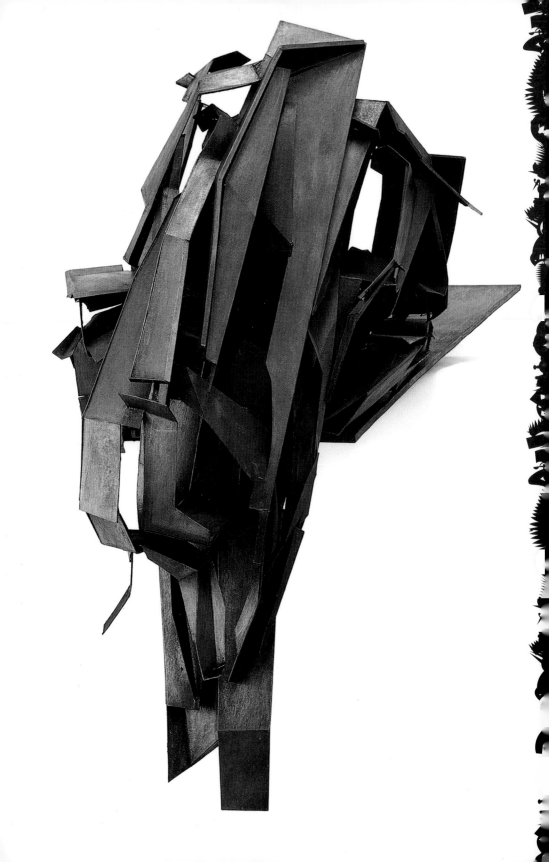

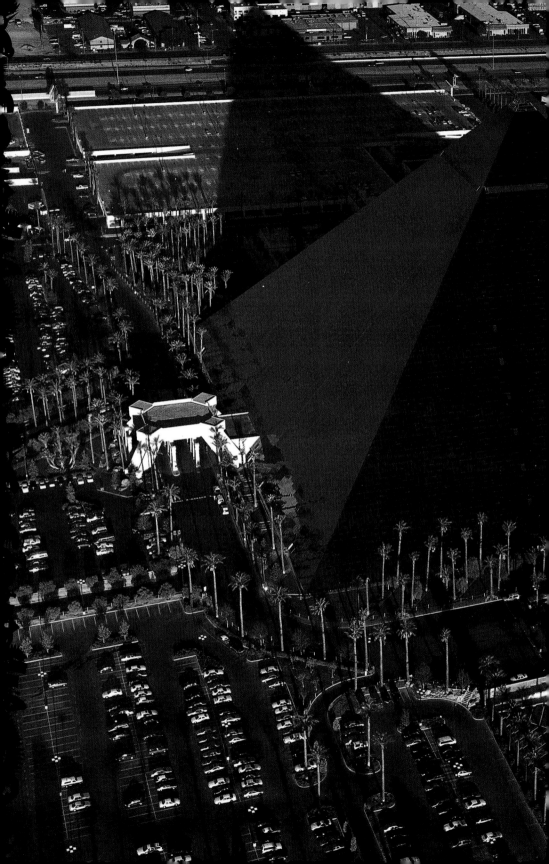

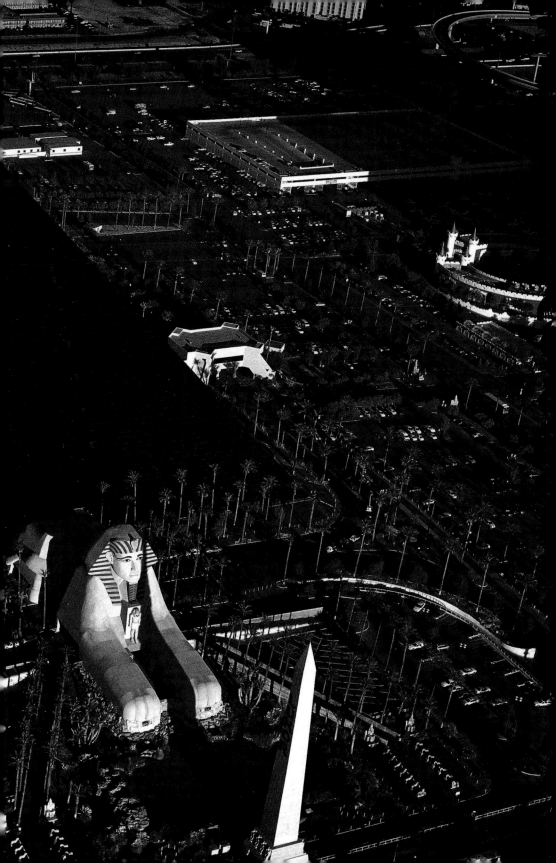

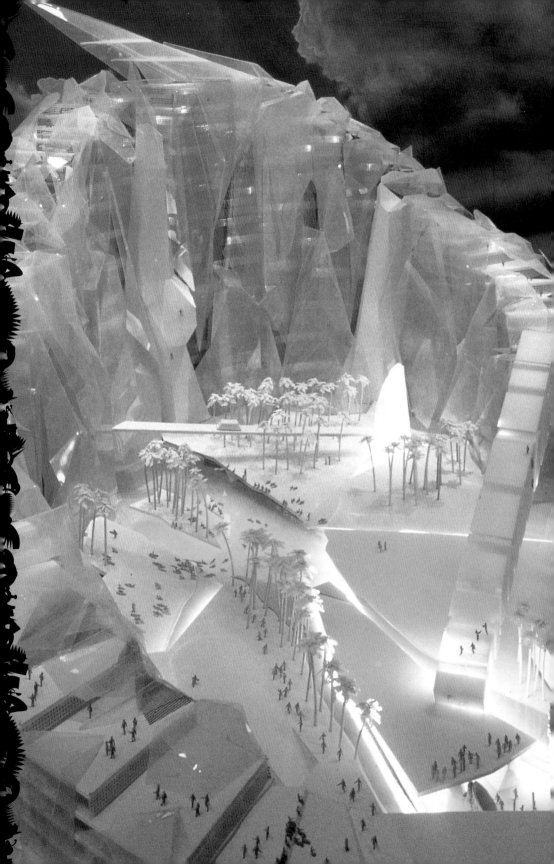

previous pages:

LUXOR HOTEL, LAS VEGAS, 1995, MARILYN BRIDGES

Bridges photographed the hotel from the air, showing the sphinx that both guards the hotel's entrance and indicates the iconography that the abstract shape of the building lacks. The area to the right is now occupied by a two-thousand-room addition.

ATLANTIS HOTEL MODEL, 1993, ANTOINE PREDOCK

Predock's entry in a competition to design a one-billion-dollar casino in Las Vegas proposed to resurrect the mythical world of Atlantis as an iceberg-vortex rising out of the desert. A different design for the casino is to be constructed.

FISH LAMP, 1984, FRANK GEHRY

This object was commissioned by Formica Corporation to explore the potential of its Colorcore product. The form of the lamp supposedly came about when Gehry threw the pieces of this integrally colored laminate to the ground in frustration and found that the pieces looked like a fish, his emblem of perfection and a memory from his youth.

right top:

STANDARD STATION, AMARILLO, TEXAS, 1963, ED RUSCHA

This image is part of a series in which Ruscha obsessively redrew a gas station—with a perspective reminiscent of that of the Twentieth Century Fox logo—before creating one painting that shows it on fire.

right bottom:

LUXOR HOTEL ATRIUM, 1996, VELDON SIMPSON

For the first four years of the hotel's existence, its main interior space (more than 100,000 square feet of gambling) was taken up by stage sets that housed high-tech rides exploring visions of the past, present, and future. Their stories offered justification for the hotel's strange appearance.

238

building is ominous. It is so dark that the own-
ers have a hard time illuminating it from the
outside. This mixture of exoticism and danger is
one of the attractions of a place like Las Vegas.
The form of the Luxor is also pragmatic. The
wide base floorplate allows for a hundred thou-
sand square feet of gambling, while at the
upper levels, the higher, more exclusive floors,
taper to ever smaller floorplates. As the volume
slims at the top, the amount of space that has
to be air conditioned becomes smaller. Yet the
Luxor's efficiency cannot quite explain the full
force of its apparition on the landscape. It is
familiar to us as a gridded glass form that
takes its place in a world of office buildings and
other structures we construct in a similar man-
ner, and its shape makes a reference, however
fanciful, to its desert surrounding. In both
cases, however, it reverses our usual under-
standing of such ways of building: it is an
expressive, rather than a neutral, building, and
it is an alien form in the landscape.

The Luxor Hotel looks the way it does because
of its function and site, but many architects are
currently trying to achieve similar effects
exactly to frustrate our all-too-easy readings of
the forms they produce. Designers such as
Antoine Predock, Herzog & de Meuron, and

SKETCH FOR LATE ENTRIES: CHICAGO TRIBUNE TOWER COMPETITION, 1980, FRANK GEHRY

The original, 1923 competition called for proposals for "the most beautiful building in the world." In Gehry's hands, the tower becomes a gigantic being that hulks over the gridded city of Chicago, confusing the animate and the inanimate in one evocative form.

Frank Gehry create buildings that assimilate
the complexities of our urban environment into
shapes that somehow seem appropriate and
alien at the same time. Such buildings make us
aware of the ability architecture has to con-
dense our activities, give shape to something
we cannot name, and stand as a fortress
against those forces we would like to keep out.
At once emblems of paranoia and places of
seduction, these heroic objects invite us to
imagine structures beyond the rigid forms that
contain our everyday lives.

top:

NELSON FINE ARTS CENTER, ARIZONA STATE UNIVERSITY, TEMPE, 1989, ANTOINE PREDOCK

The Nelson Fine Arts Center is a mass of walls rising out of the confusion of the Valley of the Sun to shelter a museum, performance studios, and theater, all grouped around a small, man-made oasis.

bottom:

PHOENIX CENTRAL LIBRARY, 1995, WILLIAM P. BRUDER, ARCHITECT, LTD.

In this image of the library that Bruder designed with longtime associate Wendel Burnette, the library stands revealed as a "ship of the desert" and a "man-made mesa" next to the highway. This double reading gives a sense of both weight and speed to this amorphous urban agglomeration.

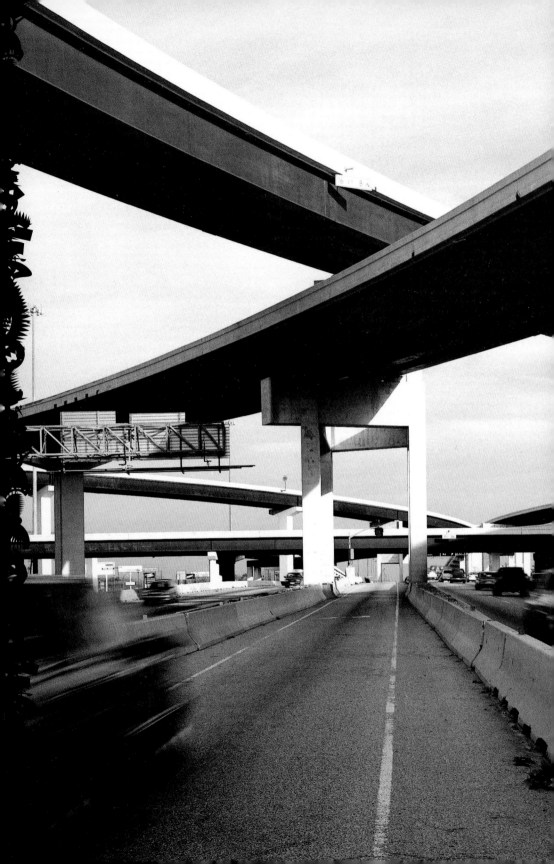

FREE WAYS

ICONIC FOUNDATIONS

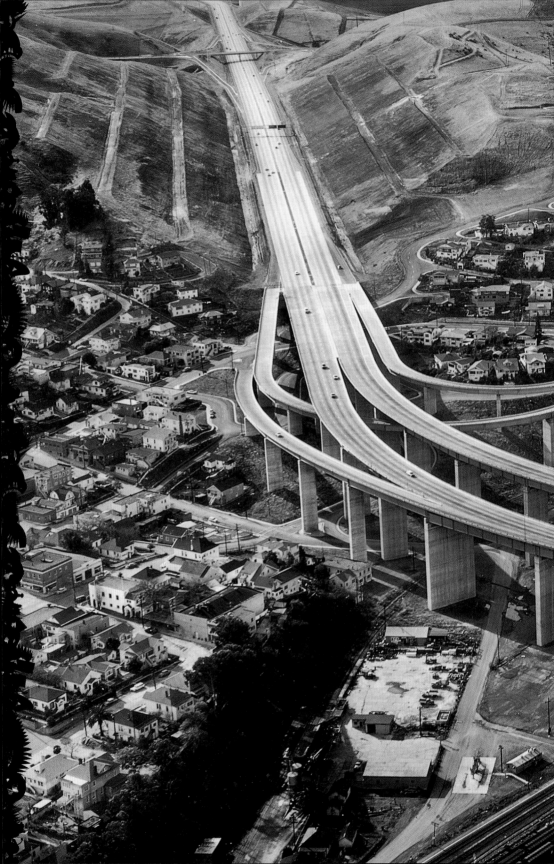

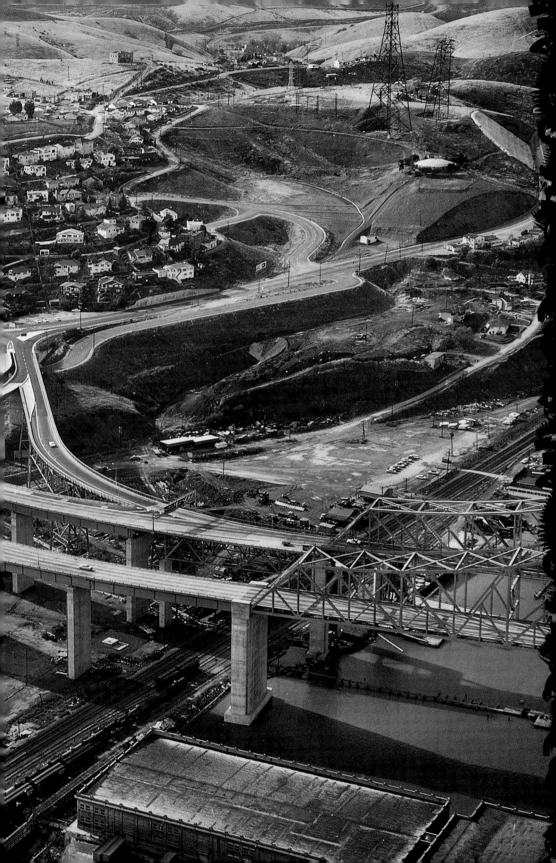

previous pages:

SAM HOUSTON TOLLWAY AS SEEN FROM INTERSTATE 10, 1997, DENNIS IVY

The tollway forms a belt around the whole city of Houston, marking its current edge. Here it intersects the main east-west highway to form a gateway to the city.

APPROACH TO CARQUINEZ BRIDGE, CALIFORNIA, 1960s, CALIFORNIA STATE DIVISION OF HIGHWAYS

The Carquinez Bridge spans the strait between the Suisun and San Pablo bays, and this photo shows the road flying off of the embankment to accomplish this bridging.

right top:

UNTITLED, 1989, MING FUNG AND CRAIG HODGETTS

Commissioned by SFMOMA for the "Visionary San Francisco" exhibition, this view of a shantytown Bay Bridge of the future illustrates a story by the cyberpunk author William Gibson.

right bottom:

SKETCH OF FINAL PROPOSAL FOR A FREEWAY INTERCHANGE IN AKRON, OHIO, 1966, LAWRENCE HALPRIN

Halprin is a landscape designer who has been responsible for some of the more elegant freeway designs in the country, including that of I-280 in the Bay Area. His interest here is to show the freeway unfolding from the landscape.

In a fundamental sense, the only constant in this country is the development and redevelopment of space on top of and around a hidden infrastructure. Cars and capital demand that our cities keep growing into ever more amorphous forms fed by increasingly invisible forces that range from water and power to microwave transmissions. Giving shape to this change that has made the "non-place urban realm" so much a part of urban life is a difficult task, and it seems as if only engineers have been able to do so. Our dams, our electric poles, our satellite dishes, our airports, and especially our highways are the clearest expressions of a form of economic and physical fluidity. This shape is nothing more or less than the physical expression of the continual motion of escape. In highway interchanges, the urban sprawl surrounding us becomes a physical node we can experience.

One of the most spectacular arias in our automotive opera occurs at the interchange between the Sam Houston Tollway and Highway I-10, twelve miles west of Houston. There, the tollway erupts into an expressionistic pile-up of ramps, vaulting as high as 120 feet above the ground. The sweeps may be just the normal curves designed by traffic engineers to allow a car to make the 50-mile-an-hour transition from

OPERATING DIAGRAM FOR THE SAN JOAQUIN REGION, 1981, PACIFIC GAS AND ELECTRIC COMPANY

Power comes into the Central Valley from various high-capacity lines connected to the Pacific Intertie system, but it is also generated at several local refineries and factories. The result is an almost incomprehensible maze.

road to road, but the articulated paring down of all the elements makes them seem as if they are celebrating speed, not just accommodating it. The interchange is also a gateway to and from Houston. As such, it becomes a triumphal arch. To drive under the Sam Houston and follow the lines of its beams as they are held up like flying acrobats by the arms of the concrete pillars, or to trace the dizzying array of ramps as they peel off the swooping datum of the main highway, is to be caught up in the magic of engineering. To turn one's head then to the sides of the road is to fall back into the broad and messy world of development, where the path of Manifest Destiny has been replaced with a beautiful road to nowhere.

Seeing the majesty of these forms only makes us realize the complexity of the forces shaping what seems to be a formless urban landscape. In a similar manner, we can never understand how water is collected in dams, tunneled to the city, kept in, and distributed to our homes or offices, or how our power in San Francisco comes from the Pacific Intertie, one of many interstate electrical distribution systems that link together the regions of this country. Yet the colorful diagrams engineers use to trace these lines of distribution are representations

top:

HOUSTON, 1993, LUCIANO RIGOLINI

Rigolini took snapshots of various cities around the world, trying to find their most characteristic aspects. In Houston, he settled on the then just completed Sam Houston Tollway.

bottom:

LA PALOMA COUNTRY CLUB (HILL), TUCSON, ARIZONA—4TH GREEN, 1994, SKEET MCAULEY

In the eerily empty and smooth world of country clubs, McAuley finds an almost surreal contrast to the articulate and prickly nature of the surrounding desert.

of the metropolitan forces hidden underneath the pavement. Our survival in the world of layered artifices that make up our cities depends on a strange reality of diagrams.

In that always changing world, we establish a space for ourselves in the landscape by planting, claiming, and owning. The smooth lawn, the golf course, the parking lot, and the building pad are all abstractions of the land around us. Through our activities, we turn that endless continuity of space into a human place.

In the forms of engineering and development, the contours of our culture solidify into often bizarre shapes. We cruise through or past these highways, lawns, and waterworks, often without noticing them. It is their very camouflage, their emptiness, and the sense that they control our movements that give these behemoths, often caught only in the rear-view mirror, their power.

top:

SEISMICITY, 1995, LEBBEUS WOODS

This is part of the "San Francisco Project," commissioned by SFMOMA. In these drawings, Woods tried to make visible the hidden instability inherent in the San Andreas fault and its associated fault system. The result is a dense texture of seemingly unintelligible structure.

bottom:

LOS ANGELES PROTOSITE S: HOUSE—NO. 4N, 1990, NEIL DENARI

Denari explored a variety of suburban and exurban living situations and community centers to find the most pared-down technological statements that he felt could stabilize this continually changing urban field. His structures are flexible and yet armor-plated monuments to a world of sprawl.

SE—NO.4N

ELEV 208.16

SF MOMA

ICONIC MONUMEN-TALITY

The San Francisco Museum of Modern Art is one of the latest and most powerful icons of a city whose foremost economic function these days is to attract visitors. Sited next to the Moscone Center, the Museum takes its place alongside the Golden Gate Bridge, the Transamerica Pyramid, and the cable cars as a symbol of the City by the Bay. It is also the largest museum of modern art on the West Coast, and it perfects the ability of such institutions to protect and exhibit some of the most beautiful, haunting, and critical containers of our cultural legacy.

Museums have become our modern churches. They are where we go to worship something, whether it is an expensive jewel, a painting, or a dinosaur bone. Over the last two centuries, their form has become reduced to a container with as few openings as possible. They resemble either jewel boxes containing great riches or defensive bunkers, but they are also large structures that soar above their surroundings and house objects of ethereal splendor. The exterior of such buildings denotes importance and civic pride, while the interior creates a frame that can be manipulated to exhibit work for maximum visibility and enhancement of its value—much in the manner of a department store.

previous page:

SAN FRANCISCO MUSEUM OF MODERN ART DESIGN SKETCH (DETAIL), 1991, MARIO BOTTA ARCHITETTO

Here the Museum is shown as a base to the surrounding skyscrapers, its central shaft abstracting their spires and its symmetry focusing the urban setting.

right:

NEXT CUBE, 1986, FROGDESIGN GLOBAL CREATIVE NETWORK FOR NEXT SOFTWARE, INC.

Designed by frogdesign, the Cube embodied the power of the new operating system and computer that Steve Jobs produced after he left Apple. The square black shape contrasts with the beige, low-profile appearance of most other mini- and microcomputers.

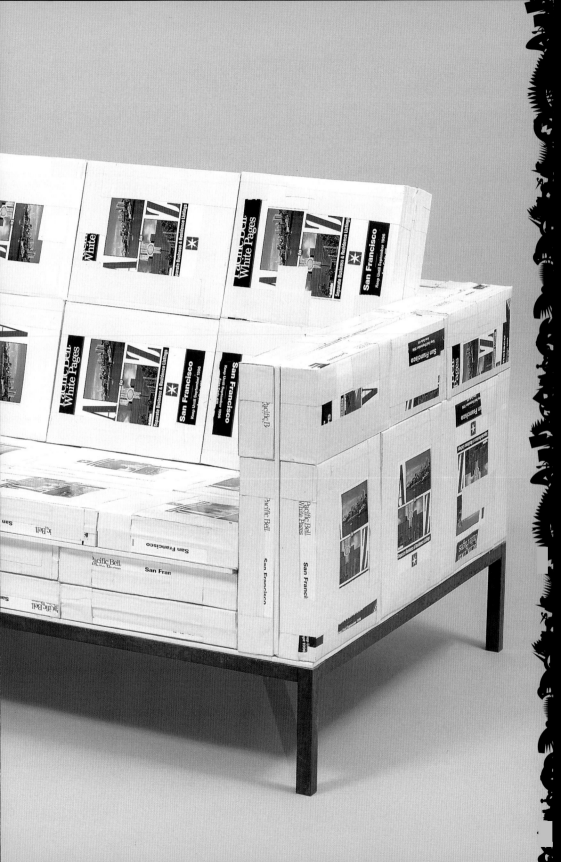

previous pages:

KNOLL LOVESEAT, 1996, TOM SACHS

Sachs took the frame of this loveseat, designed by Florence Knoll in 1959, and replaced its cushions with telephone books held together with duct tape. The interiors of the phone books have been carved to provide structural stability and smooth appearance with reduced weight.

AXONOMETRIC UPVIEW OF GARDEN, CITY WALL, AND PAVILION OF THE MUSEUM FOR NORDRHEIN-WESTPHALIA, DÜSSELDORF, 1975, JAMES STIRLING, MICHAEL WILFORD, AND ASSOCIATES

Stirling drew these confusing views of the central parts of his buildings to reveal the voids and connections that permeated his designs. Here his slices through the mass of the building were meant to transform the interior of the museum into a pathway and courtyard.

TOWER 1-16, 1996, CESAR RUBIO

Sutro Tower marks the top of one of the highest hills in San Francisco, sending radio and television signals into the ether while standing in contrast to the smooth undulations of the hill. Completed in 1973, it is our own Eiffel Tower or Statue of Liberty, shorn of celebratory or ideological content.

right:

ALCATRAZ MASTER PLAN MODEL, 1988, HOLT HINSHAW PFAU JONES ARCHITECTURE

This architecture firm proposes transforming the former penal island into a marine mammal center and hostel. Thus, the technology of incarceration is used to expound on the imposition of cultural artifacts on the landscape forms of the Rock.

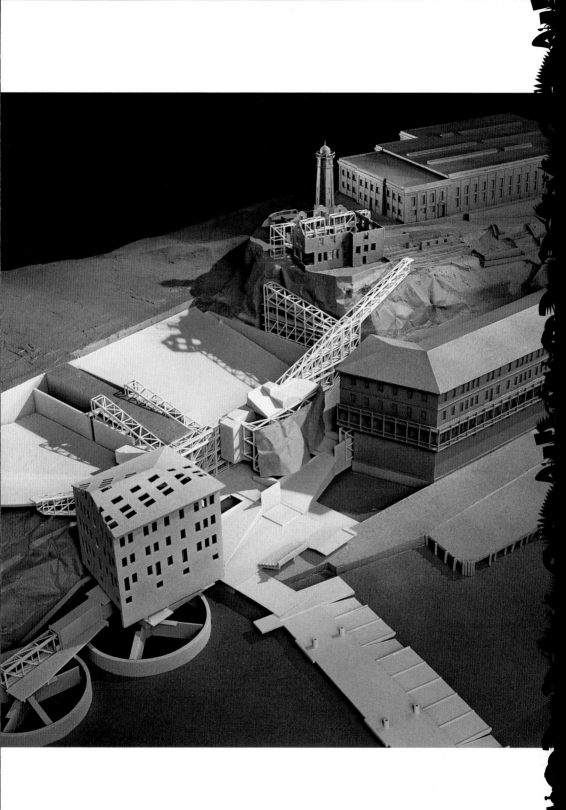

The San Francisco Museum of Modern Art, designed by Mario Botta and opened in 1995, is a foursquare brick-clad box that faces a new public space in the city, Yerba Buena Gardens, and steps up to take its place as a public object in a forest of speculative skyscrapers. Its symmetry and geometric blocks reinforce the sense of importance that its size and closed form already impart at a glance. Yet the central slot slices open the box, so that we are given a hint that riches are stored inside. Out of that slot, the tower of the church of culture rises up. Its spire is lopped off to become a skylight, the very emblem of museums of art. The interior of that gesture becomes a rotunda, where people gather and pass each other on their way to viewing the art. The core of the building is not so much the artwork but an internalization of the city's stores, restaurants, vertical streets, and squares.

San Francisco is a city whose craggy forms mimic the uplifted terrain that geologic action left behind. The best constructions in the city trace and celebrate that physical condition: the Golden Gate Bridge turns into a triumphal arch the one gap in the land through which much of the water coming down from the Sierra can flow, while the Transamerica Pyramid is a

top:

SAN FRANCISCO MUSEUM OF MODERN ART PRESENTATION MODEL, 1991, MARIO BOTTA ARCHITETTO

Having condensed the blocks and geometries of earlier proposals, Botta arrived at this design in 1991. The building was completed, essentially as depicted here, in 1995.

bottom:

TRANSAMERICA PYRAMID, 1995, REGIS LEFEBVRE

Lefebvre has photographed the pyramid from almost all angles for its owner, Transamerica Corporation. The tower's shape was meant to evoke California redwoods while allowing more light to penetrate into lower floors.

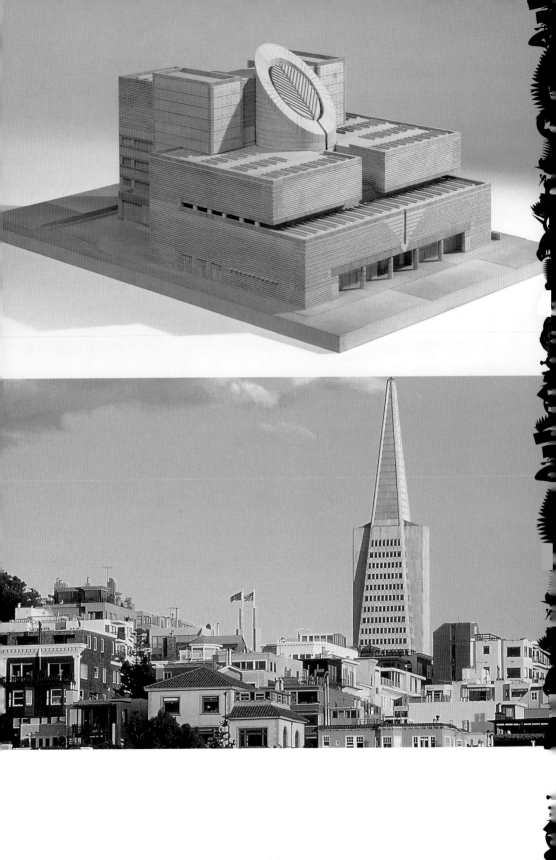

triangle, the most stable form and thus the one best able to withstand earthquakes. Architects fantasized about how they could harness the flow of water or the history of this place that was founded as the first defensive settlement in what appeared to western settlers as an alien land, and their experiments became civic proposals for museums, desalination plants, or exhibition spaces on Alcatraz. The geography also made the city into a jewel set between the expanses of the Pacific and the plains of the Central Valley, and this building is a faceted stone in that civic crown.

The Museum seems to be a refinement of tectonic lift and a history of both defense and accumulation, here tamed and focused into two plates containing a spire. Inside of all this motion, made possible by the landscape and our ability to transform its potential into a metropolitan experience, lies a treasure trove of modern art that questions the world outside. At the very heart of our notions of high culture, the San Francisco Museum of Modern Art creates an emblem of place and abstract meaning.

top:

MUSÉE À CROISSANCE ILLIMITÉ (THE ENDLESS MUSEUM), 1939, LE CORBUSIER

Le Corbusier envisioned a museum that would spiral ever outward from a central entrance reached from beneath its forest of columns. Here art is housed in a liberated, autonomous object that is not perfect in shape but that is always changing within the bounds of a simple geometry.

bottom:

1996 PACIFIC BELL SMART WHITE PAGES, 1996, PACIFIC BELL

When it opened in 1995, the San Francisco Museum of Modern Art took its place with cable cars and Fisherman's Wharf as a San Francisco icon.

Pacific Bell® White Pages

A to Z

Separate Business & Residence Listings

San Francisco

Keep Until September 1996
Area Code 415

trademarks of KitchenAid USA, photo by Ben Blackwell; p. 195: courtesy of Braun, Inc.; pp. 196–97: courtesy of Williams-Sonoma; p. 199: courtesy of Limn Company, Inc.

Pages 201–250
Page 201 top: courtesy of Limn Company, Inc.; p. 201 bottom left: photo courtesy of Landmark Group; p. 201 bottom right: courtesy of Swatch; p. 203 top: courtesy of Ecco Design, Inc.; p. 203 bottom: courtesy of Dyson Appliances, Ltd.; p. 204: courtesy of CBS Broadcast Group; p. 206: Collection of Maynard Garrison, photo by Ben Blackwell; p. 207: photo by Ben Blackwell; p. 209 top: courtesy of Nike, Inc.; p. 209 bottom: Collection of the Whitney Museum of American Art, New York, photo by Geoffrey Clements; p. 211 left: Collection of Michael Friedman; p. 211 right: courtesy of the Walt Disney Company, photo by Ben Blackwell; p. 213 top: courtesy of Chermayeff & Geismar, Inc.; p. 213 center and bottom: courtesy of Apple Computer, Inc.; p. 215 top: Collection of Ken Friedman; p. 215 bottom: Collection of Michael Friedman, photo by Ben Blackwell; pp. 218–19: Collection of the San Francisco Museum of Modern Art, gift of the artist, 96.306, photo by Ben Blackwell; p. 221: Collection of the San Francisco Museum of Modern Art, gift of Tomato, 97.26.A-B., © Tomato; p. 223 top: Collection of the San Francisco Museum of Modern Art, gift of the artist, 96.307, photo by Ben Blackwell; p. 223 bottom: Collection of the San Francisco Museum of Modern Art, gift of Rudy VanderLans and Zuzana Licko, 96.81, photo by Ben Blackwell; pp. 224–25: © Wired Ventures Inc., design and production assistance by Eric Easton, Emily Tucker, and Barbara Kuhr; p. 227: Collection of the San Francisco Museum of Modern Art, gift of Rudy VanderLans and Zuzana Licko, 96.82, photo by Ben Blackwell; p. 229 top: Collection of the San Francisco Museum of Modern Art, gift of Rudy VanderLans and Zuzana Licko, 92.12, photo by Ben Blackwell; p. 229 bottom: Collection of the San Francisco Museum of Modern Art, gift of Rudy VanderLans and Zuzana Licko, 92.22, photo by Ben Blackwell; p. 230: courtesy of the artist; p. 233: Collection of the San Francisco Museum

of Modern Art, Accessions Committee Fund; pp. 234–35: photo © Marilyn Bridges; p. 236: photo © 1994 Robert Reck, courtesy of Antoine Predock Architect, FAIA; p. 237: courtesy of Fred Hoffman Fine Art, photo courtesy New City Editions, Venice, California; p. 239 top: Collection of the Hood Museum of Art, Dartmouth College, Hanover, New Hampshire, gift of James J. Meeker, class of 1958, in memory of Lee English, photo by Hood Museum of Art; p. 239 bottom: photo courtesy of Luxor Las Vegas; p. 241: Collection of Deborah Doyle, photo courtesy of Frank O. Gehry & Associates, Inc.; p. 243 top: photo © Timothy Hursley; p. 243 bottom: courtesy of William Bruder, Architect, Ltd., photo © Bill Timmerman; p. 244: courtesy of Dennis Ivy, Houston, Texas; pp. 246–47: courtesy of the California State Division of Highways; p. 249 top: courtesy of Hodgetts + Fung Design Associates; p. 249 bottom: reprinted from the book *Freeways*, by Lawrence Halprin (New York: Reinhold Publishing Corporation, 1966).

Pages 251–65
Page 251: courtesy of Pacific Gas and Electric Company, photo by Ben Blackwell; p. 253 top: courtesy of the artist; p. 253 bottom: courtesy of Christopher Grimes Gallery, photo © 1995 Skeet McCauley; p. 255 top: Collection of the San Francisco Museum of Modern Art, 96.86, photo by Ben Blackwell; p. 255 bottom: courtesy of COR-TEX ARCHITECTURE, photo by Ben Blackwell; p. 256: Collection of the San Francisco Museum of Modern Art, purchase, 94.205, photo by Ben Blackwell; p. 259: Collection of the San Francisco Museum of Modern Art, gift of NeXT Software, Inc., 96.238, photo by Ben Blackwell; pp. 260–61: Collection of the San Francisco Museum of Modern Art, Accessions Committee Fund, 95.240.1, photo by Ben Blackwell; p. 262: courtesy of the James Stirling Foundation; p. 263: courtesy of the artist; p. 265: photo © Douglas Symes, courtesy of Holt Hinshaw Pfau Jones Architecture; p. 267 top: Collection of the San Francisco Museum of Modern Art, photo by Ben Blackwell; p. 267 bottom: courtesy of the artist; p. 269 top: courtesy of la Fondation Le Corbusier; p. 269 bottom: courtesy of Pacific Bell.

About the Authors

Aaron Betsky is curator of architecture and
design at the San Francisco Museum of Modern
Art, a position he has held since March 1995.
Previously, he was coordinator of special pro-
jects at the Southern California Institute of
Architecture. He is the author of several books
on architecture, including *Building Sex: Men,
Women, Architecture, and the Construction of
Sexuality* and *Queer Space: The Architecture of Same
Sex Desire*, and is a contributing editor of
Architectural Record, ID Magazine, Blueprint, and
Metropolitan Home.

Steven Flusty is a doctoral student in the School
of Urban Planning and Development at the
University of Southern California. He is the
author of *Building Paranoia: The Proliferation of
Interdictory Space and the Erosion of Spacial Justice*,
as well as of numerous articles tracing com-
modity chains as a means of investigating
everyday globalization.

David E. Nye is professor and chair at the
Center for American Studies, Odense
University, Denmark. He is the author of
American Technological Sublime and *Electrifying
America*, which received the Public Works
Historical Society's Abel Wolman Award and
the Society for the History of Technology's
Dexter Prize.

Chee Pearlman, who has written extensively on
design, is the editor-in-chief of *ID Magazine*, the
leading design publication in the United States
and the winner of the 1995 National Magazine
Award for General Excellence. She is also
co-chair of the Chrysler Award for Innovation
in Design and serves on the national board of
the American Institute of Graphic Arts.